IMAGES
of America

TONAWANDA AND
NORTH TONAWANDA

This 1895 map illustrates the importance of the geographical location of the Tonawandas. These two villages were at the easternmost end of the navigable upper Great Lakes, situated at the juncture with the Erie Canal. After its completion in 1825, the Erie Canal provided the easiest link between the upper lakes and the Atlantic coast. Tonawanda's spacious natural harbor and miles of river shoreline, exposed to desirable westerly breezes off the river, made the site ideal for storing, drying, and processing lumber. (Courtesy of the Historical Society of the Tonawandas.)

ON THE COVER: Around 1895, lumber schooners and schooner barges crowd Tonawanda Harbor during the height of the lumber industry's dominance in the twin villages of the Tonawandas. The small community grew astronomically once lumber barons of the day realized and seized upon the site's ideal location for the processing of lumber. In the early 1890s, the port was the second largest lumber-handling center in the world, second only to Chicago. (Courtesy of the Historical Society of the Tonawandas.)

IMAGES
of America

TONAWANDA AND
NORTH TONAWANDA

Historical Society of the Tonawandas

ARCADIA
PUBLISHING

Published by Arcadia Publishing
Charleston, South Carolina

Printed in the United States of America

Library of Congress Control Number: 2010934601

For all general information, please contact Arcadia Publishing:
Telephone 843-853-2070
Fax 843-853-0044
E-mail sales@arcadiapublishing.com
For customer service and orders:
Toll-Free 1-888-313-2665

Visit us on the Internet at www.arcadiapublishing.com

HISTORICAL SOCIETY
OF THE TONAWANDAS

1961 2011

Fifty Years Of Service
To The Twin Cities

This volume is dedicated to the memory of city historians
Willard Dittmar and Robert Lloyd for having the foresight 50
years ago to establish a Twin Cities historical society.

CONTENTS

ACKNOWLEDGMENTS

The Historical Society of the Tonawandas gratefully acknowledges all of those who have contributed to the publication of this book during our 50th anniversary year. The photographs contained herein are a small sampling of the thousands that have been donated to the society for safe keeping over the 50 years since our inception. It is because of the individual concern of one donor after another, who has taken the time to put aside an old photograph or artifact for the society to preserve, that we have amassed such a comprehensive array of historic photographs, providing a glimpse at life in the Tonawandas since their earliest settlement—almost 200 years ago—up to the present.

We also thank those volunteers who have spent hours upon hours researching, identifying, and indexing these photographs so that they are now accessible to anyone interested in the history of our two cities. And finally, we are honored to acknowledge all those who have supported the Historical Society of the Tonawandas during the past 50 years, both financially and otherwise, enabling us to have the time and facilities to preserve and make available the wealth of history entrusted to our stewardship.

For this publication in particular, the Historical Society of the Tonawandas is indebted to the crew who has assembled, scanned, extensively researched, and captioned these 200-plus images from our collection. This crew consisted of Pat Barnard, Janet McKenna, Alice Roth, Ned Schimminger, John Slater, and Terry Wegler. Unless otherwise noted, all images are from the historical society's collection.

INTRODUCTION

We, the city historians of Tonawanda and North Tonawanda, are pleased to provide in this introduction an abridged history of the Tonawandas, from their inception in the early 19th century up to the 1960s. This is the same period that is represented by photographs and captions in this new publication from the Historical Society of the Tonawandas. This synopsis is based on the work and files of the late Willard Dittmar, former City of Tonawanda historian and cofounder of the historical society.

The lumber industry that defined the Tonawandas for close to a century began back in 1833, when the East Boston Timber Company purchased 16,000 acres on Grand Island and began cutting the great white oak trees that were growing there. These huge timbers were transported to the company's shipyard in Boston Harbor, which was where they were used in construction of the famous Yankee Clipper ships, the fastest ocean craft of their day.

Headquarters of the company was located on Tonawanda Island, where Stephen White, the head of the company, built a magnificent mansion, from which he directed operations. Steam sawmills, the largest in the world, were erected on the Grand Island shore, opposite Tonawanda and along the mainland. By 1840, however, the oak trees had all been cut down, and the company sold their holdings on Grand Island for farming purposes.

The Erie Canal, which had opened in 1825, together with the natural harbor facilities along the Niagara River gave the lumber industry a renewed impetus. Timber from the forests of Minnesota, Michigan, Wisconsin, and Canada were shipped to the Tonawandas. Logs, in the form of huge rafts, were towed from Canadian and Michigan points to the local area. As many as 100 million logs were shipped to the Tonawandas in a single season.

At the turn of the 20th century, Tonawanda and its neighbor to the north became jointly known as "Lumber City," the largest lumber supply center in the world. As many as 40 to 50 lake lumber carriers, known as lumber "hookers," anchored in Tonawanda Harbor during the winter months. In 1890, two local customs offices reported a total of 1,422 vessels entering and 1,412 vessels clearing the Tonawandas.

Lumber docks extended for a distance of 6 miles along the river, from Two Mile Creek to Gratwick. Lumber was unloaded onto these docks from the ships by gangs of men, often referred to as lumbershovers or dockwallopers.

Along with lumber, shingle making became an important part of the local scene. Not only were white pine shingles imported, but in 1890, the local mills were also manufacturing about 100 million of them.

The railroads, competing with the shipping interests for the immense lumber freight business of the Tonawandas, extended their tracks throughout the area and gave the shipper a great advantage as far as rates were concerned. During 1906, a total of 86,611 cars were handled in and out. This placed the Tonawandas as the third largest producer of original freight in the state of New York, being exceeded only by New York City and Buffalo.

The extensive supply of lumber in the Tonawandas led to the development of other industries dependent upon wood for their final products. Not only were ships sailed into and out of the area, but many types were also built here. The F. N. Jones shipyard was located at the confluence of Tonawanda Creek and the Niagara River and constructed steam yachts to oceangoing vessels, which weighed around 3,000 tons. A dozen or more Erie Canal boat yards were located along Ellicott's Creek. Later the Niagara Boat Company, the Disappearing Propeller Boat Company, and the Richardson Boat Company produced pleasure crafts of great distinction, which were known the world over. During World War I, concrete canal boats were produced, and in World War II, landing craft and U.S. Army vessels were built on Tonawanda Island.

Merry-go-round horses and animals were hand carved from wood, and the Armitage-Herschell Company, which later became the Allan Herschell Company, was the largest manufacturer of carousels in the world. Merry-go-rounds led to the manufacture of band organs by DeKleist's Musical Instrument Works. This in turn led to the establishment of the great Wurlitzer organ factory, the largest of its kind in the world, which made the "Mighty Wurlitzer" theater organ.

The availability of wood pulp and the excellent shipping facilities resulted in the manufacture of paper and its related products by the Tonawanda Board and Box Company and the International Paper Company. There were many other smaller industries in the Tonawandas, too numerous to mention.

In the beginning of the 20th century, the forests in the timber producing states were quickly depleted, and as no trees were replanted in those areas, the source of supply was eventually exhausted. The shrinking lumber business, however, was being replaced with other industries, notably what were known as heavy industries.

The manufacture of iron and its related steel industries became a close rival of the lumber business for the place of first importance in the Twin Cities. The Tonawanda Iron Company consumed hundreds of thousands of tons of iron ore annually from the rich iron mines of the upper lakes. The Buffalo Bolt Company, the largest manufacturer of nuts and bolts in the world, was located here. Radiators, engines and boilers, structural steel, steam pumps, gasoline motors for automobiles and boats, and many other forms of machinery and manufactured iron were extensively made in the Tonawandas. Remington Rand, the world's largest maker of steel filing equipment, originated here and was started by a local man.

All of the previously mentioned world-famous industries and manufacturers eventually disappeared from the Tonawandas. To fill the void, scores of light manufacturing concerns sprang up throughout the Twin Cities. Most of these called for skilled and semi-skilled help.

The transition from lumber to other industries took place gradually but steadily. The disappearance of the heavy industries and the birth of the light industries was also a gradual phenomenon, starting just after World War II. Many reasons have been given for the loss of these industries. It has been claimed that as the factories aged, the machinery and processes became obsolete, and the owners were reluctant to replace them. Many of the local owners passed away with the result that the companies were sold, moved, razed, or were merged with other companies. High taxes were blamed for the flight of many industries. Products made by several companies became old fashioned and were no longer salable. As Willard Dittmar surmised, "Perhaps the only valid reason is that times change, and industry and manufacturing ideas change with the times."

Congratulations to the Historical Society of the Tonawandas on this splendid publication marking their 50th year of preserving our heritage. May it continue its good work.

—Peter Trinkwalder
North Tonawanda City Historian

—Ned Schimminger
Tonawanda City Historian

One

GETTING STARTED

It was the early 1800s when the first settlers began to arrive along Tonawanda Creek. They found a nearly unbroken forest with only two roads to Buffalo and no bridges to cross the streams. Getting around was difficult; one had to be strong, daring, and resourceful to survive. These settlers were among the new nation's first westward pioneers.

In the spring of 1823, Samuel Wilkeson and Dr. Ebenezer Johnson were authorized by the Erie Canal Commissioners to begin the construction of a dam and lock at the mouth of Tonawanda Creek. The purpose of the dam was to raise the water level of the creek 4.5 feet so the stream could be used for canal navigation without dredging. This was the first work done on the western end of the Erie Canal. In the same year, a group of Buffalo men, "believing that a considerable town would gather here," purchased land and laid out a village and streets. In 1824, George Goundry, Col. John Sweeney, and his brother James also began advertising and selling building lots. After the opening of the canal in 1825, settlement slowly increased. By the time the Benjamin Long family arrived in 1828, there were only 13 buildings along the canal banks. But the Longs had come to farm and purchased the property at the confluence of Ellicott Creek and Tonawanda Creek. Little did they know that the sylvan quietude of their new home would soon be broken by the onslaught of the lumber industry, starting with the arrival of the East Boston Timber Company in 1833.

By 1850, over 100 families had settled in the area, the lumber industry was growing and prospering, and an assortment of retail establishments had cropped up along the canal. Soon Tonawanda would become a village.

Born August 21, 1786, in Carmel, New York, John Sweeney was residing in Buffalo in 1813, when he joined the Geneva Volunteers as a lieutenant. He served in the blockhouse that was built to protect Tonawanda during the War of 1812. Wounded at the Battle of Queenston, he returned to Tonawanda in about 1815 to become one of the most prominent businessmen in the area, who was also active in land speculation and promoting the area.

New York governor DeWitt Clinton advocated building a canal from Albany to Buffalo to facilitate trade and western settlement. In 1817, the state legislature authorized $7 million for the construction of a canal 363 miles long, 40 feet wide, and 4 feet deep. Dug by hand, the Erie Canal opened in 1825. Tonawanda and North Tonawanda's roots are part and parcel of the history, development, and lore of "Clinton's Folly." (Courtesy of the New York State Archives.)

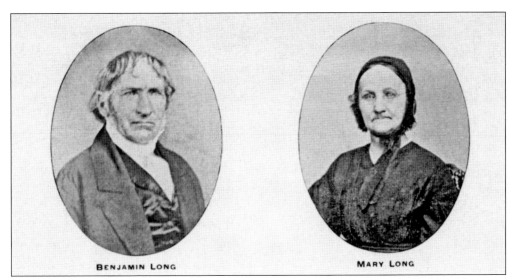

BENJAMIN LONG MARY LONG

In 1829, Benjamin and Mary Hershey Long built their new home on a point of land between Ellicott Creek and the Erie Canal. The Longs had traveled with their five daughters, ranging in age from six months to 16 years, from Lancaster, Pennsylvania. At the time, only 13 buildings encompassed the area north and south of the canal. Many Tonawandans can trace their ancestry to the Long family.

The East Boston Timber Company, headquartered on Tonawanda Island, is credited with initiating the growth of the lumber industry in the Tonawandas. Company president Stephen Whit, constructed this magnificent mansion on the island, where he lived with his daughter, Caroline. His company shipped fine white oak from their 16,000 acres of land on Grand Island to their shipbuilding facility in Boston, Massachusetts. (Caroline White married Daniel Webster's son, Fletcher.)

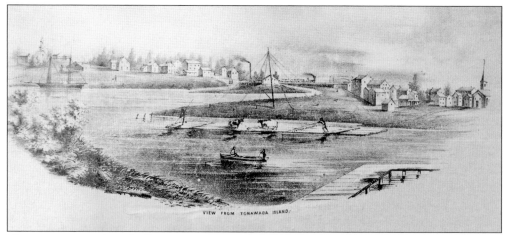

This engraving is the title illustration on an 1857 map of "The Village of Tonawanda in Erie and Niagara Counties," drawn by Tobias Witmer. The *View from Tonawanda Island* clearly includes some artistic license but provides some sense of the place early Tonawandans called home. Unfortunately for the mapmaker, the village would split in two before the maps were paid for, which led to considerable debate over who should pay for them.

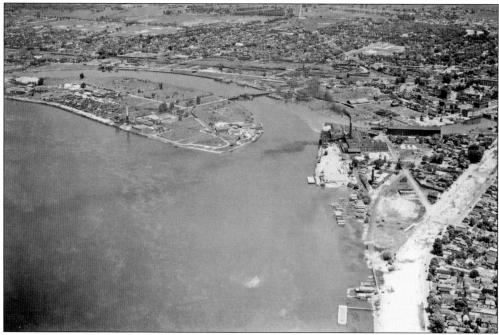

Tonawanda's natural harbor and connectivity with the Upper Great Lakes and the Erie Canal made it the ideal location for the development of the lumber industry that defined the early growth of the settlement. As it leaves the downtown area headed for Buffalo, the old Erie Canal bed, now filled in, can be easily discerned at the far right. In the late 19th century, these waterways were generally jammed with lumber boats.

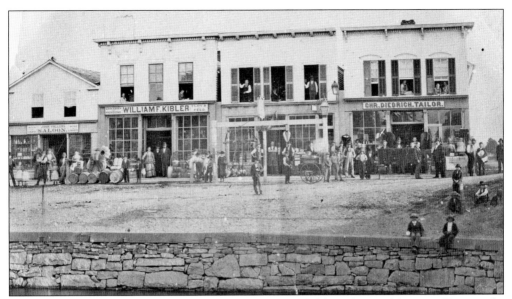

Taken in the 1870s, this is one of the earliest photographs of old South Canal Street in Tonawanda. The road slopes up to meet Seymour Street at the far right. Residents of the two growing villages shopped in stores lining the canal on both North Canal and South Canal Streets. The four buildings seen here housed Haller's Saloon, Kibler's Feed and Flour Store, a harness shop, and Diedrich's Tailor Shop.

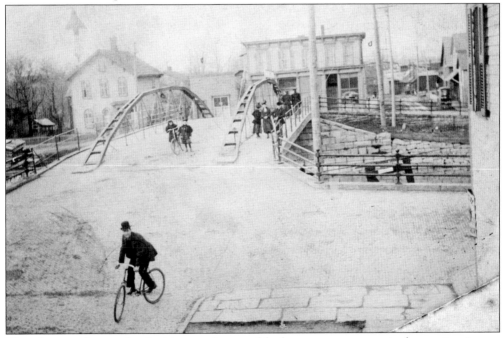

This photograph was taken looking north at roughly the same area as seen in the previous image. The Seymour Street Bridge crosses the Erie Canal toward Goose Island. The prominent building across the bridge sits where the foot of the Seymour Street Bridge ramp is today. Just to its right, the viewer can just make out the railroad swing bridge, which still sits today at the same location, near the mouth of Tonawanda Creek.

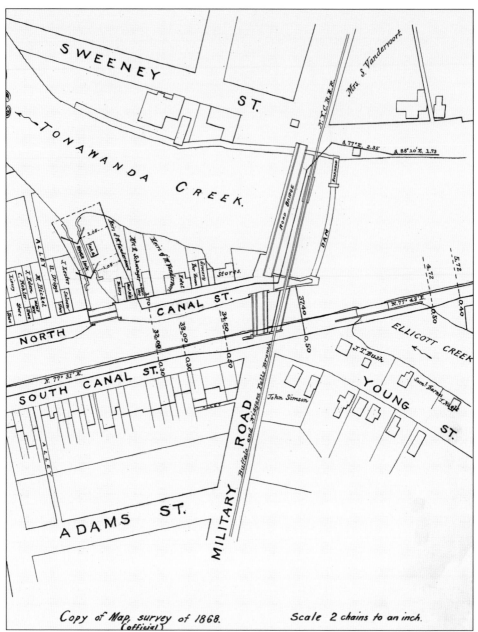

Copy of Map, survey of 1868.
(official)
Scale 2 chains to an inch.

This 1868 survey map provides a clear illustration of the configuration of the streets, waterways, and buildings that defined the heart of the twin villages for close to 70 years. The dam across the mouth of Tonawanda Creek raised the level of the creek 4 feet and diverted it into the man-made channel that ran to Buffalo, parallel to the Niagara River. The majority of merchants' shops were on either side of this canal in the south village. The old Military Road and the Buffalo and Niagara Falls Railroad ran from the north to the south through the center of town. Two end-to-end bridges over the canal and the creek provided pedestrian and wagon passage between the two villages. This basic configuration remained in place until about 1920, when the dam was removed, the canal westward to Buffalo was abandoned, and the railroad route was diverted to bypass the center of town.

Two

WATER, WATER
EVERYWHERE

Local historians believe the name Tonawanda is Native American in origin and means "swift water." On early maps, it is spelled "Tonewanta" and appeared as the name of a creek that originated in a Wyoming County spring and flowed westerly into the Niagara River, thus connecting with the Great Lakes system. An 1824 Erie Canal Commissioners' report described Tonawanda as "the place where The Most Extensive Internal Natural Navigation Upon Earth, connects with the Longest Line of Unbroken Artificial Navigation Ever Produced by the Labor of Man, and in the immediate Vicinity of the Greatest Water Power for Moving Machinery in the World." They concluded that the village of Tonawanda was ripe for development. Throughout the 1800s, because of the Erie Canal and the natural harbor facilities available, the lumber industry grew and prospered just as the canal commissioners had predicted. At the turn of the 20th century, Tonawanda and its neighbor, North Tonawanda, jointly known as the "Lumber City," were among the largest lumber supply centers in the world.

However, this abundance of water created several huge problems. Drowning was common, not only of people but also mules and horses. There was also the associated loss of boats, carts, and cargo. Flooding was another problem. So a ditch was dug that extended from the river, just south of Bouck Street, through Tonawanda to Ellicott Creek. This state ditch was supposed to prevent flooding. It did not. In fact, areas along its path experienced severe flooding from heavy spring rains and snow melt. Residents were forced to use boats to get around. Eventually the ditch was deepened, and the flooding reduced. Additionally, the many bridges needed to negotiate all these waterways created an ongoing traffic and maintenance headache. With the advent of trains, more bridges were required. At one time, the Tonawandas had over a dozen bridges within their borders.

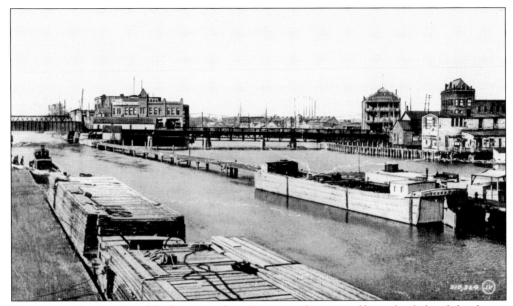

This view of the Erie Canal, looking west from Gastown, shows canal boats loaded with lumber in the canal (left) and Tonawanda Creek (right). The New York Central and Hudson River Railroad Bridge and the Long Bridge are shown in the middle of the photograph. In the background is the First Trust Company on the Tonawanda side of the canal (left) and Scanlon Hall and the State Trust Company in North Tonawanda (right).

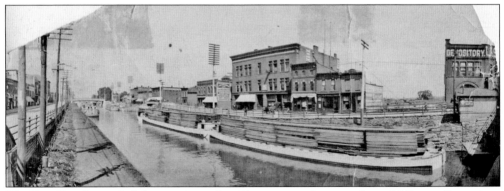

The Erie Canal provided the activity and traffic patterns that transformed Niagara Street into a business thoroughfare. This section of the canal has now been filled in and is part of Niagara Street. The Sunshine Mission and O'Connor's Ship Chandlery are seen here on North Niagara Street. Note the towpath along the canal that was once used by teams of mules and horses. In the distance is the Seymour Street Bridge crossing over the canal.

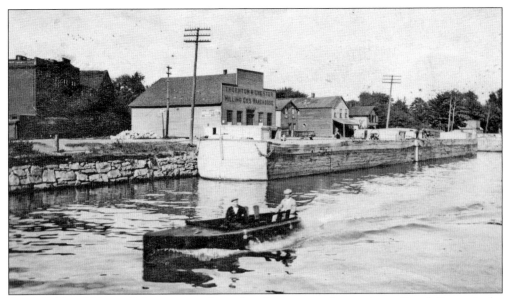

Frank (left) and George Schweitzer are shown heading west on the canal near Bouck Street. In the background to the right is the Thornton and Chester Milling Company warehouse at 154 North Niagara Street. The old Vinegar Works Clay Street facility on Goose Island is to the left.

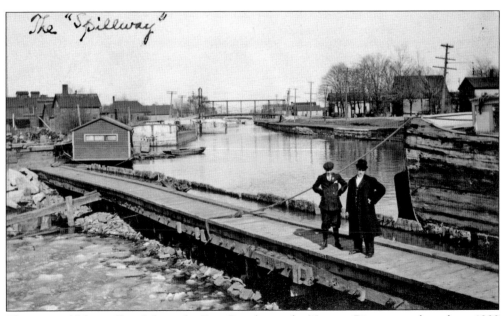

This view of "the spillway" from the Erie Canal into the Niagara River was taken about 1908 near the present site of the Miller Bandshell in Niawanda Park, looking east. The Bouck Street Bridge crosses the canal in the distance. The houses at left are on Goose Island; the houses on the right are on South Canal (now South Niagara) Street. The two gentlemen are Harold Stumpf and Sam Merklinger.

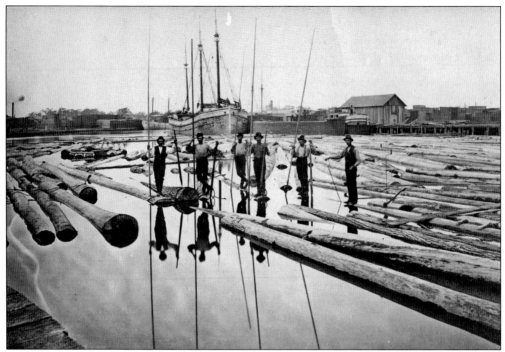

From left to right, Matt Scanlon, Pat Scanlon, Dan Burd, William Sutter, Martin Scanlon, and an unidentified individual are shown here rafting in Tonawanda Creek around 1869. Rafts were large quantities of logs lashed together with chains for transportation on the lakes. In port, rafters, sometimes called loggers, guided the logs into the sawmills. A lumber schooner and canal boat *John C. Baker* are in the background. Tonawanda Island is at the left.

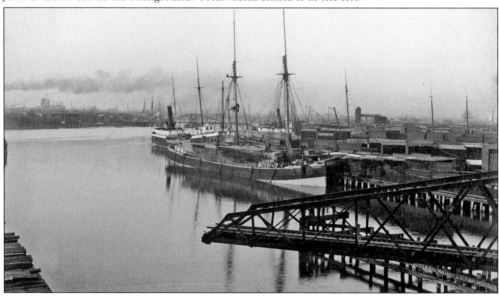

In this view looking north, taken on March 18, 1887, one can see the following: (center) schooner *C. B. Jones*, built in 1873, and steamer *P. H. Birkhead*; (lower right-hand corner) the New York Central and Hudson River Railroad Swing Bridge; (right) North Tonawanda lumberyards; and (in the background at left) Tonawanda Island lumberyards.

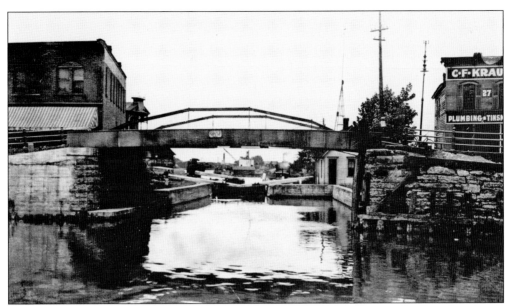

Looking north into the opening of the Tonawanda Lock, which connects the Erie Canal with Tonawanda Creek, the lockkeeper's house can be seen beyond the North Canal Street Bridge. The building that housed the C. F. Krauss Plumbing and Tinsmithing shop was once a bakery.

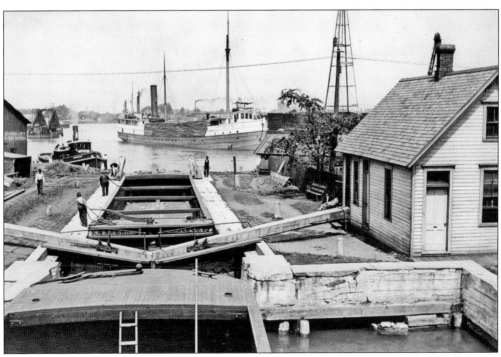

This 1912 view of the Tonawanda Lock shows an Eastern Lumber Company lighter (a barge) in the lock and the tug *Constitution* at the left. A fully loaded Edward Hines Lumber Company lumber hooker has just passed the open railroad swing bridge that connects the Goose Island section of Tonawanda with North Tonawanda. The weather tower (right) was used for displaying weather signal flags for the lower lakes.

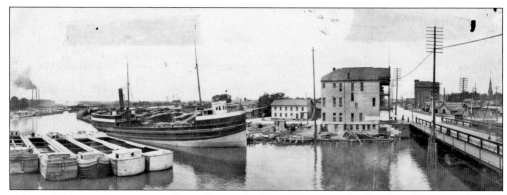

Taken with a rotating camera from the south side of Tonawanda Creek in Tonawanda, this photograph from about 1910 shows the lumber hooker *John B. Ketcham II*, lumber barges, and the Long Bridge that joined the Twin Cities. The four-story Scanlon Hall (Niagara Frontier House) housed a hotel, a large assembly hall, and a bar that served fine cuisine to tourists, commercial travelers, and bicyclists. The White Star Hotel is to the left of Scanlon Hall.

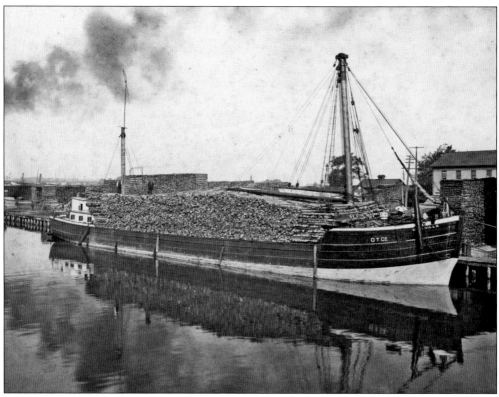

The schooner-barge *Unadilla* was built in 1862 by the Peck and Masters Shipyard in Cleveland, Ohio, and remained in service until December 1913. It was believed to have been named after the original owner's hometown of Unadilla, New York, located about 35 miles northeast of Binghamton. It is shown moored in Tonawanda Creek at the foot of Manhattan Street in North Tonawanda with a load of cedar fence posts.

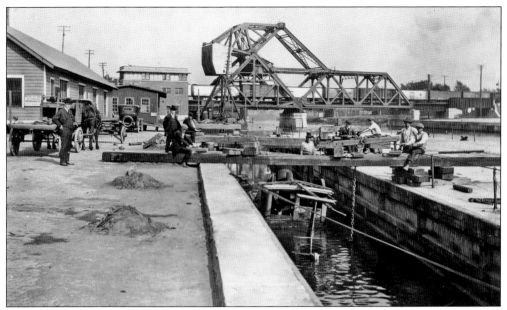

Mover Frank Geltz (second from the right with hat and suspenders) and his men prepare to raise the tug *Clinton T. Horton* that had sunk in the lock on the North Tonawanda side of the canal. A New York Central freight train can be seen crossing the railroad's canal bridge in the background, which is also where one gets a rare view of the Central's interlocking tower to the left of the bridge.

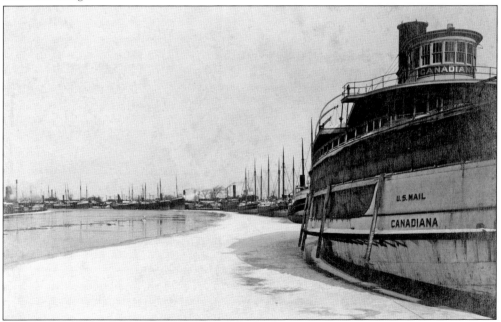

It is the winter of 1911 and the *Canadiana*, of the Buffalo-Crystal Beach Line, joins the fleet of vessels harbored in the Little River, just off North Tonawanda. Launched at the Buffalo dry dock in May 1910, the *Canadiana* would be the last passenger vessel constructed in Buffalo. The "Crystal Beach Boat" plied the waters of the Great Lakes until 1956. After years of preservation efforts, it was cut up for scrap in 2004.

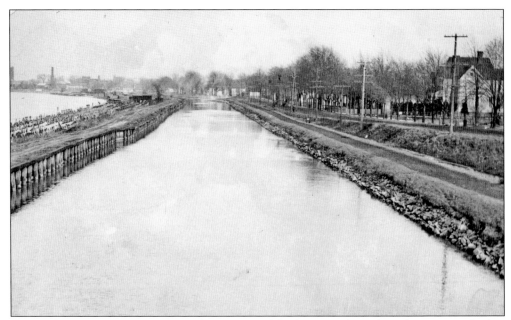

This early-20th-century view shows the Erie Canal, looking east from the Gibson Street Bridge. The towpath and a tree-lined South Niagara Street can be seen to the right, while the berm separating the canal from the Niagara River is on the left. The large house seen at the right was the home of local contractor Louis H. Gipp and was located at 433 South Niagara Street.

Looking west at Two Mile Creek, the old Erie Canal is seen at the right, and Ringler's Farm is at the extreme left. The old saloon and roadhouse on River Road is now the site of the Isle View Inn, and Isle View Park is where the canal was once located.

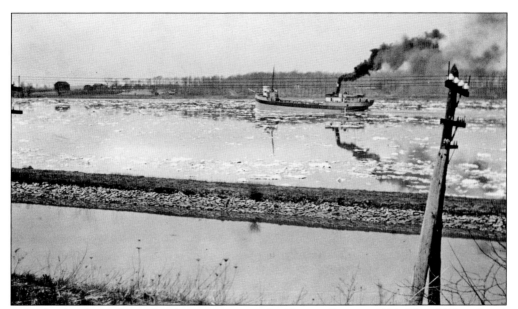

A lumber hooker is shown heading upstream in the Niagara River in 1924. The old Erie Canal is in the foreground, and Grand Island can be seen in the background. A lumber hooker was a self-propelled lumber vessel that often towed companion lumber barges.

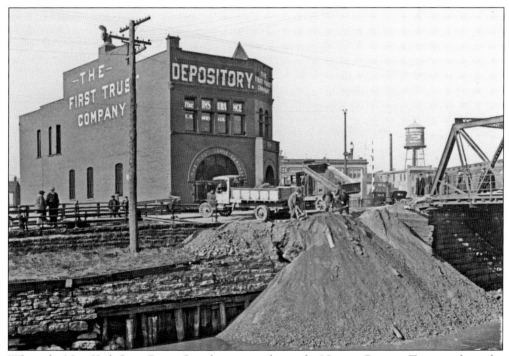

When the New York State Barge Canal was routed into the Niagara River at Tonawanda in the early 1920s, the project began to fill the old Erie Canal bed between Tonawanda and Buffalo. In the photograph, dump trucks are beginning the fill process just west of the Main Street Canal Bridge. The First Trust Company Building on North Niagara Street is shown in the background.

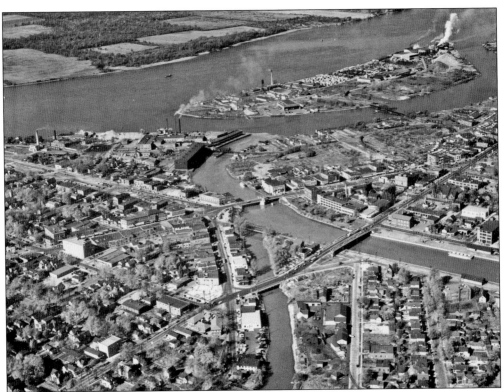

This photograph, a candidate for the mural in HSBC Bank, clearly shows the many waterways of the Tonawandas. Ellicott Creek, entering from the bottom, flows into Tonawanda Creek, which in turn flows into the Little River, separating Tonawanda Island from the rest of North Tonawanda. The old Erie Canal, which ran down the Niagara Street right-of-way (left), is now filled in. The Niagara River and Grand Island are in the distance.

This June 1947 view of the Niagara River and Tonawanda Island looks north from the small boat docks near the bend in Niagara Street in the vicinity of the old state ditch. The Tonawanda sewage disposal plant was several hundred feet to the right.

Boathouses and Wardell's Boat Yard have replaced acres of lumber piles that once filled this corner of North Tonawanda by the Little River. The only significant lumber remaining is the massive pile of logs at the International Paper Company at left, beyond the swing bridge to Goose Island. The owner of the small pontoon boat (center) is unidentified; many locals purchased supplies for such boats from army surplus after World War II.

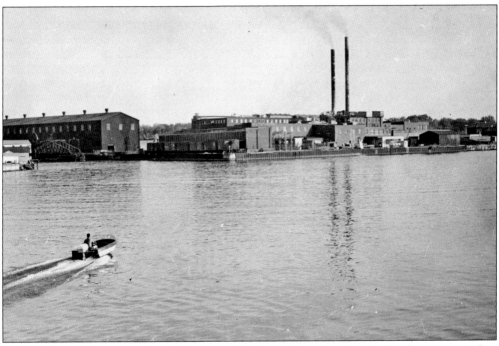

In 1901, Lewis Newman selected Tonawanda's Goose Island as the site for the country's first all-electric paper mill. The Tonawanda Board and Paper Company opened on Clay Street in 1903, and the large facility would become an iconic part of the city's shoreline. The mill was purchased by the Robert Gair Company in late 1926 and, after a complete overhaul, reopened as the Tonawanda Boxboard Division.

Both Tonawanda and North Tonawanda had a state ditch, the generally unsuccessful purpose of which was to control flooding during the spring months. The state ditch in Tonawanda, shown here, ran from Ellicott Creek, along State Street, to Main Street, and then between Bouck and Kohler Streets, down to the Niagara River. This photograph shows the Broad Street culvert crossing the state ditch.

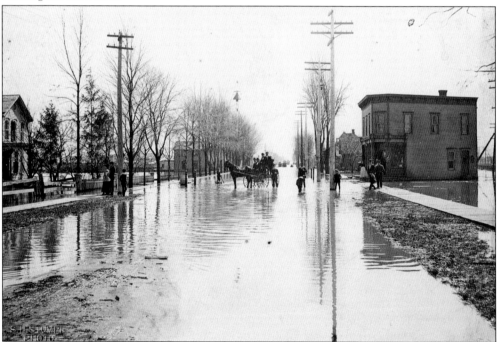

In the spring of 1823, New York state constructed a dam near the mouth of Tonawanda Creek so that canal water levels could be raised and lowered by as much as 4 feet to avoid the need for dredging. Melting snow and ice and spring rains would cause the state ditch to overflow and cause serious flooding problems. Shown here is Main Street, near Hill Street, about 1900.

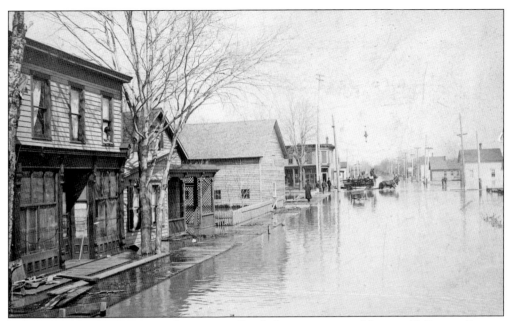

A horse and wagon are pictured crossing a flooded intersection at Main and Minerva Streets. Springtime flooding was a common occurrence when waters in the state ditch overflowed. Canal workers recommended widening the ditch to prevent flooding and to control the volume of water entering the ditch from other streams. On April 25, 1910, the legislature of New York appropriated $4,000 in a canal appropriation bill to implement this recommendation.

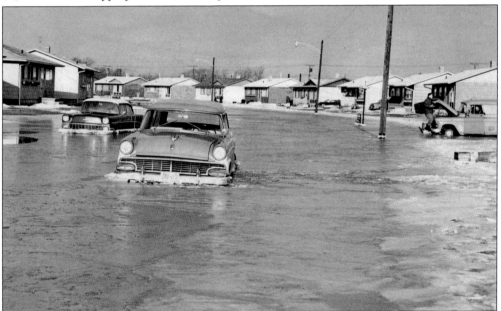

In the late 1950s and early 1960s, the Millstream section of Tonawanda experienced continual flooding problems. Heavy rainstorms caused basement flooding in homes throughout the area, even though the city's sluice gates were operating properly. It was discovered that during heavy rainstorms, the large volume of rainwater flowing through downspouts, connecting to storm and sanitary sewers, overloaded the system, resulting in basement backups and flooding.

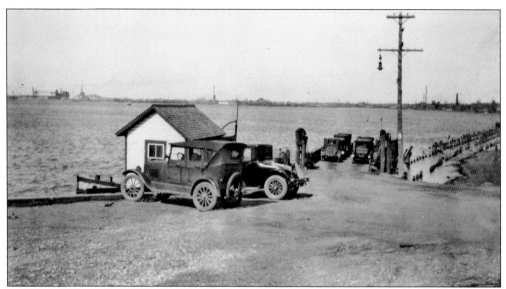

On Sundays and holidays, cars would line up at the Gibson Street ferry landing for trips to Grand Island. Popular destinations on the island included Edgewater, an amusement park on East River Road, and the Bedell House. When the Grand Island Bridge was constructed and opened, ferry service was discontinued in July 1935.

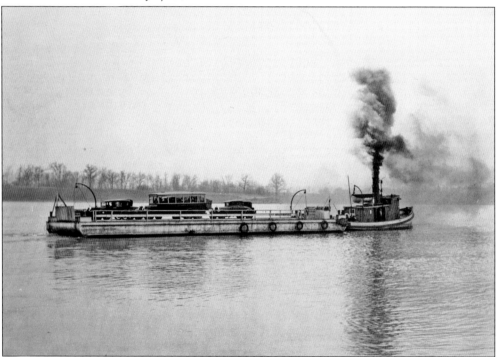

Prior to 1935, transportation to and from Grand Island was provided by ferry. The tugboat *H. W. Long*, built at the Globe Shipyard in Buffalo, towed a scow back and forth between the Gibson Street landing in Tonawanda and Grand Island. It ran daily from 7:00 a.m. to 6:00 p.m. and, in the summer, from 6:00 a.m. until 12:00 p.m. The scow carried horses, carriages, cars, and school buses, as seen in this 1924 photograph.

Three

MAKING OF THE TWIN CITIES

By the late 1800s, lumber had literally overwhelmed the Tonawandas. Houses were dwarfed by lumber that was piled high along 6 miles of shoreline. The waterways were jammed with lake schooners and canal boats. The air was filled with the sounds of sawing and the smell of white pine, mules, and horses. Sawdust covered roadways. Immigrants speaking a variety of languages added color and chaos to the scene. They had come by the thousands, across the ocean and up the canal, to find work in "Lumberland."

The natural harbor, which provided easy transportation for products by water and later by rail, and abundant lumber resources made the Tonawandas irresistible to all sorts of determined entrepreneurs. One after another, they came to seek their fortune. Clever men, arrogant men, and brilliant men were willing to risk everything on their ideas, driven by dreams of success. Many went bankrupt; some became millionaires.

The first industrialist in the area was Lewis S. Payne, who erected the first steam mill in 1847. Sommer, Schaefer, and Company started a cider, vinegar, and yeast works in 1873, which became one of the largest of its kind in the country. Most famous are the Herschell, Spillman, Richardson, Rand, and Wurlitzer names, whose families enjoyed several generations of successful business endeavors. Most amazing is the staggering range of products these entrepreneurs engineered and produced that include the following: merry-go-rounds; cruise boats and warships; pig iron; steel girders; engines; boilers; bolts; automobiles; all types of musical instruments, including player pianos, organs, and jukeboxes; plus silk garments like gloves, nightgowns, and underwear. The Tonawandas were among the largest producers in the world for many of these products and thus achieved international fame as a major industrial center. This era of productivity and prosperity lasted well into the 20th century.

William H. Gratwick Sr. (1839–1899), a prominent lumber baron and shipping magnate, established his lumbering enterprise, W. H. Gratwick and Company, in North Tonawanda. The lumber company partnered with its sister shipping company, Gratwick, Smith, and Fryer Company, to move timber from out-of-state company lands, across the Great Lakes, to processing mills in North Tonawanda. At the time of his death in 1899, William Gratwick's estate was valued to be more than $1.5 million.

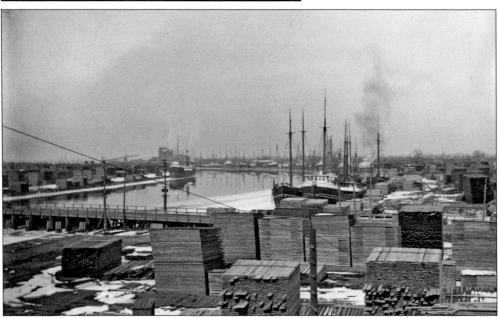

A common scene in North Tonawanda harbor in 1887 was lumber piled everywhere. Delivered by schooners, like the *Unadilla*, lumber came from Michigan, Wisconsin, and Minnesota. Also pictured is the Island Street Bridge. Tonawanda Island can be seen on the left side of the photograph and North Tonawanda on the right. For years, the Tonawandas were the second most important lumber market in the world.

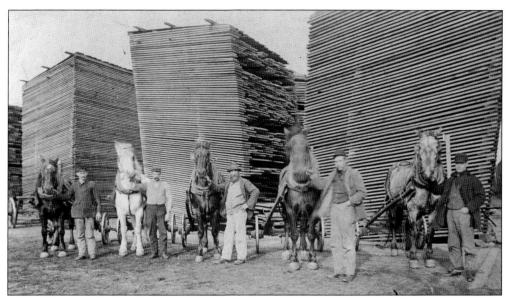

Lumber was the major economic entity in the Twin Cities at the start of the 20th century. While the majority of the local lumber firms were located in North Tonawanda, the Eastern Lumber Company was one of those situated on the south side of the canal in Gastown. Five of the company's teamsters pose in front of the sky-high piles of lumber, which dominated the shorelines throughout the Twin Cities.

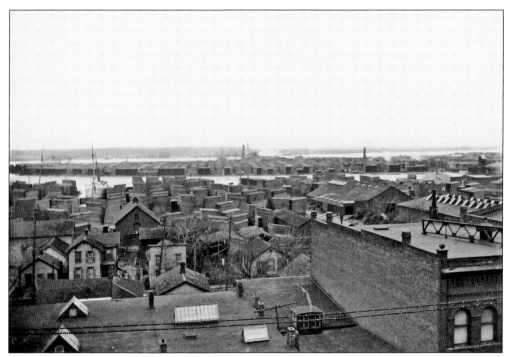

During the peak of the local lumber boom, the Tonawandas were one great lumber pile, with wood stacked solidly along the canal and river all the way from Two Mile Creek in Tonawanda to Gratwick in North Tonawanda. This photograph is looking beyond Webster Street to Tonawanda Island.

James Armitage, one of many immigrants who ventured to America in the mid-19th century, teamed up with the Herschell brothers, Allan and George, and William Gillie to form the Tonawanda Engine and Boiler Works in 1873. This firm prospered for two decades in North Tonawanda, manufacturing engines, boilers, and farm machinery, and would eventually expand into the manufacture of merry-go-rounds.

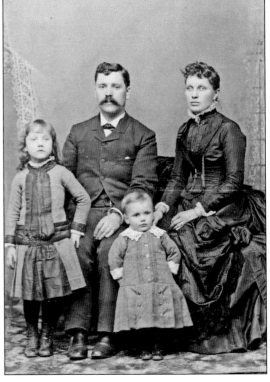

Many carrousels that are still in use today are from the Armitage-Herschell Company of North Tonawanda. Cofounder Allan Herschell, who inspired the steam-riding gallery, is shown at right with his family. He made his first carrousel in 1883. He successfully operated the business until his death in 1927, leaving his widow, Ida Spillman Herschell, to continue the tradition. The company remained in North Tonawanda until 1957.

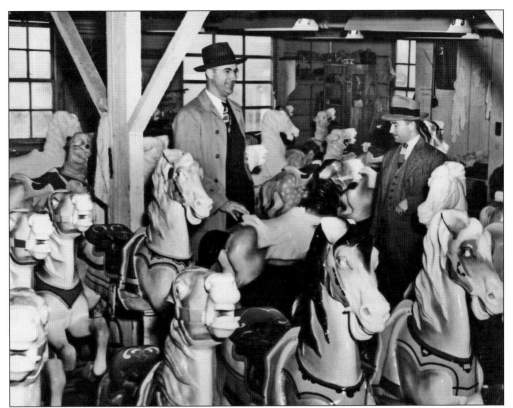

Pictured are a herd of horses, carrousel horses that is. This mid-1940s photograph shows Herschell-Spillman carrousel horses being stored. They await painting and refurbishing before being sent out to adorn amusement rides. The original Thompson Street factory is now the site of a carrousel museum that is dedicated to preserving this unique form of folk art.

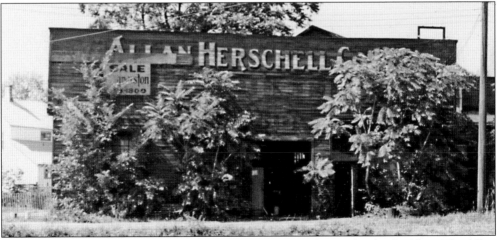

When the music ended and the horses left, all that remained was a derelict building. The Allan Herschell Company operated at this site from 1915 until 1957. One of the largest producers of carrousels, it fell on hard times as entertainment tastes changed. All is not forgotten, as the Carrousel Society of the Niagara Frontier has restored the building and now operates a working carrousel and museum at this location.

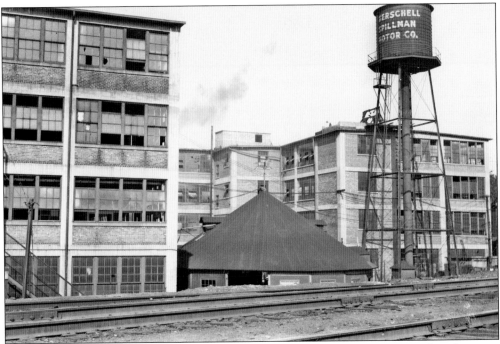

This view looks west at the Herschell Spillman Motor Company's Frontier Plant on the subsequent Sweeney Street site of Remington Rand. Note the testing roundhouse in the center of the picture. Today this building is being converted into loft apartments and retail space, including an upscale restaurant.

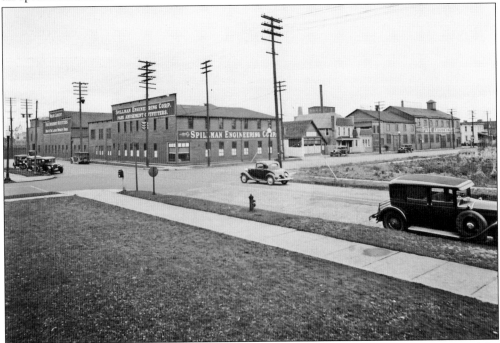

The many vintage automobiles pictured in this photograph of the Oliver Street location of the Spillman Engineering Corporation date this photograph to about the 1920s.

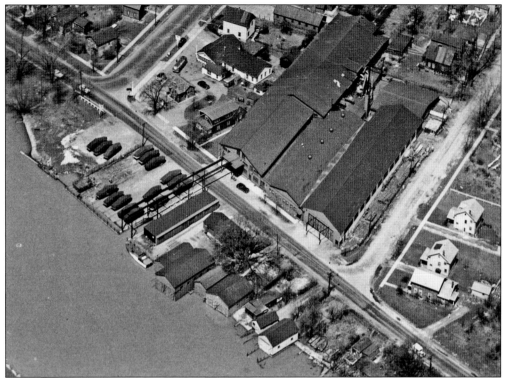

G. Reid Richardson founded Richardson Boat Company in 1909, aiming to build quality boats at a fair price. Until it went bankrupt in 1962, Richardson Boat Company turned out cruisers, sailboats, runabouts, and racing boats, as well as military vessels during both world wars. This aerial view of the factory at 370 Sweeney Street, North Tonawanda, shows the long building, center, and the launching area located on the Erie Canal.

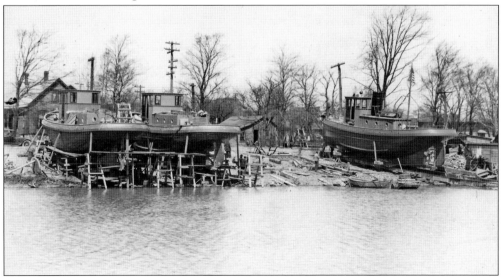

Wooden gasoline-powered tugboats, built by Richardson Boat Company for the U.S. Army in 1917, were subsequently delivered via the New York State Barge Canal. The original Erie Canal, opened in 1825, was deepened, reconfigured, and renamed the New York State Barge Canal in 1918.

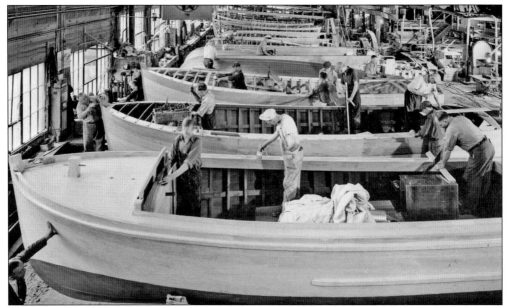

During World War II, Richardson Boat Company became a government contractor again. Workers are shown with LCVP (landing craft, vehicle personnel) vessels, the 36-foot ship to shore carriers. The firm turned out 60 units per month.

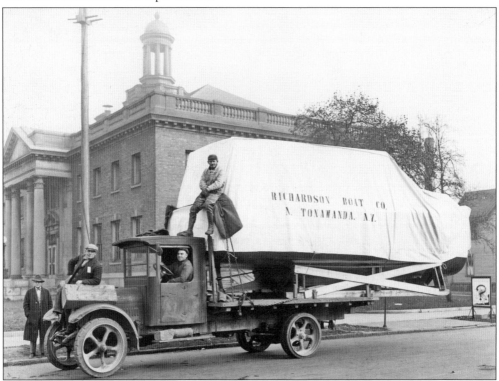

Adolph Kinzly and crew sit on their truck prior to moving a Richardson cruiser along Oliver Street. In this photograph, they are situated next to the North Tonawanda Post Office in about the 1920s.

In 1905, Rudolph Wurlitzer acquired Eugene DeKleist's North Tonawanda factory that made pianos, player pianos, band organs, and other musical instruments. The Rudolph Wurlitzer Company would become famous for production of the "Mighty Wurlitzer" organ, used in theaters worldwide, and jukeboxes that were prominent in restaurants, diners, and bars. Rudolph Wurlitzer served as company president until 1912 and was succeeded by his sons—Howard E., Rudolph H., and Farny R.

The headquarters and main plant of the Wurlitzer Company in North Tonawanda is shown with its famous flower garden in the 1940s. Begun as an importer of European musical instruments, the firm expanded into coin-operated devices, "Mighty Wurlitzer" organs and pianos. Their jukeboxes, or "coin-operated phonographs," are still collectors' items. The plant closed in 1975.

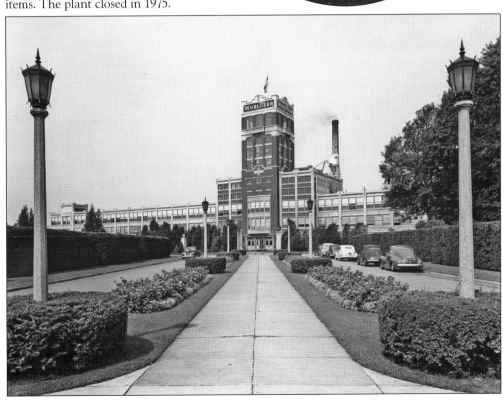

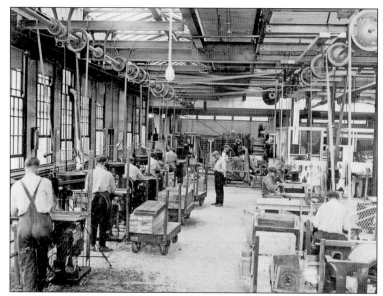

The woodworking department at the Wurlitzer plant in North Tonawanda provided cabinet components for pianos, player pianos, organ consoles, and jukeboxes. There is extensive use of pulleys to power equipment at the various workstations.

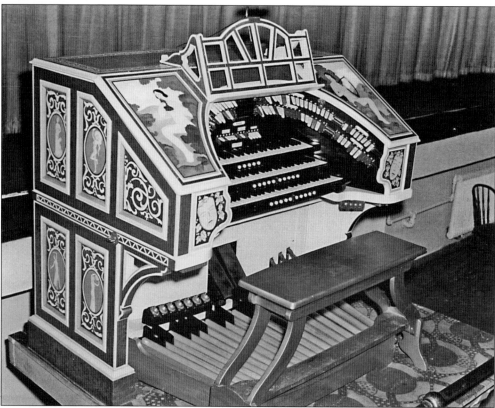

Rudolph Wurlitzer was mighty proud of the $25,000 "Great Wurlitzer" that was housed in the new Rivera Theater on Webster Street in 1926. A full-page advertisement the day before the theater's opening declared, "The Wurlitzer Organ is the musical wonder of the age." The organ, with over 800 pipes and painted with elaborate designs, ballerinas, and "classical" women, still entertains in the theater today.

This 100,000th phonograph, a jukebox, was made by the Wurlitzer Company in 1937. Jukeboxes were coin-operated record players with selection buttons. Wurlitzer was the iconic jukebox of the era and provided background and dance music in soda shops, bars, and other venues. Key company personnel pictured here are, from left to right, William Morrissey, Herman Steinig, Lloyd Tooke, Don Plant, Otto Schwartz, and Mike Gruensweig.

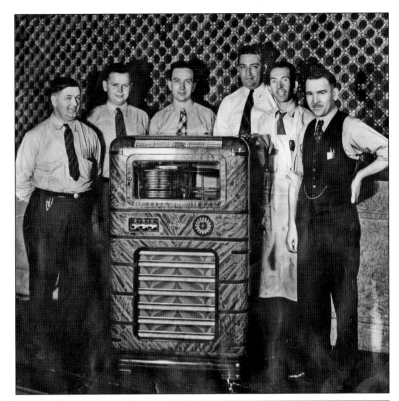

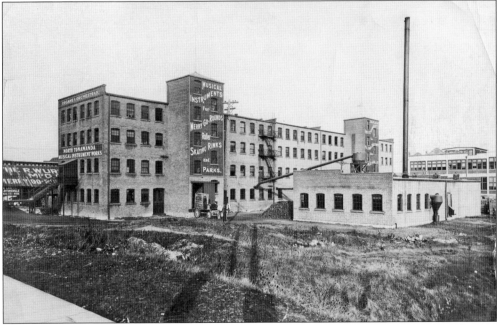

From 1906 until the late 1920s, North Tonawanda Musical Instrument Works manufactured pianos and organs for use in amusement parks, saloons, movie theaters, roller-skating rinks, and so on. The organs operated by either a pinned cylinder or perforated paper rolls and featured snappy, up-to-date music. Elaborate designs decorated the band organs and coin-operated pianos.

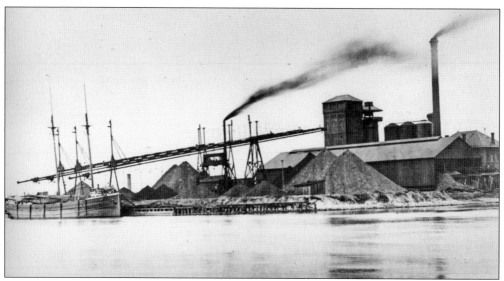

On November 5, 1896, president-elect William McKinley pressed the button that transmitted the ignition spark that started the second furnace at Tonawanda Iron Corporation on River Road. The day was hailed as the dawn of a new era of industrial sunshine for the Tonawandas. The fire from the furnaces lit the western sky every day and night for almost 100 years.

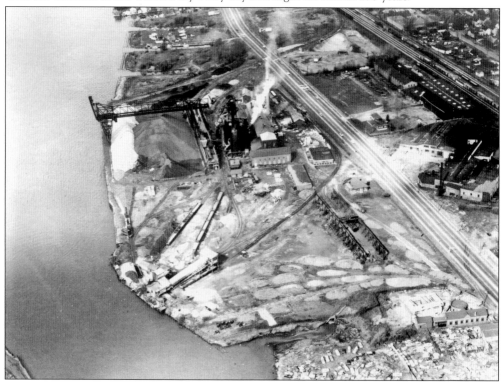

This photograph shows Tonawanda Iron Corporation with River Road to the right and the Niagara River on the left. Note the array of tracks throughout the complex. The plant had its own railroad and about 4 miles of track within the plant. One 60-ton and two 45-ton diesel locomotives were used to handle raw materials, molten metal, and slag, as well as finished product.

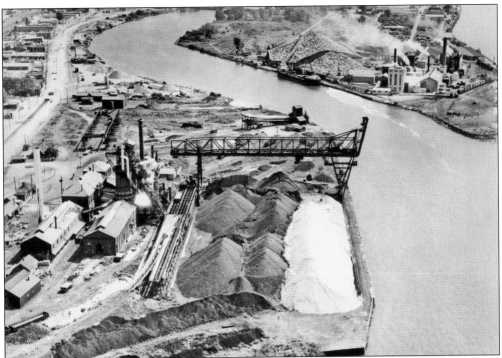

Tonawanda Iron Corporation operated on a 36-acre site at 526 River Road in North Tonawanda for 99 years. It produced 86 different kinds of merchant iron for foundry and casting industries. At its peak in 1928, employment reached 600; when it closed in 1972, a total of 160 people lost their jobs. The International Paper Company is seen on Tonawanda Island in the background.

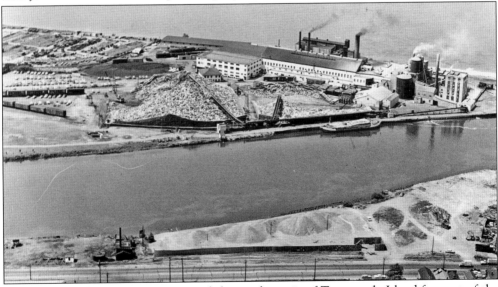

International Paper Company occupied the northern tip of Tonawanda Island for most of the 1900s. As a major producer of paper products, the plant was also a major polluter, utilizing 10 million gallons of water and burning 150 tons of coal per day. Although the plant has been demolished, the elevated "trickle tanks," used to settle out suspended solids from the water, still occupy a prominent place on Tonawanda Island.

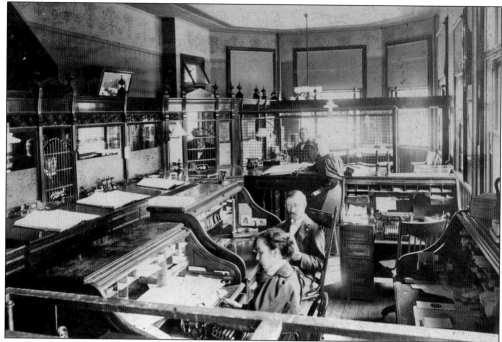

This photograph was taken inside one of James Rand's banks. The Rand family's talents went beyond banking to include inventions such as the visible ledger system. But their real genius seemed to be in business—big business—creating mergers and consolidations, which resulted in one of the largest corporations in the United States, Sperry Rand. Several Rand families lived in mansions on Goundry Street in North Tonawanda.

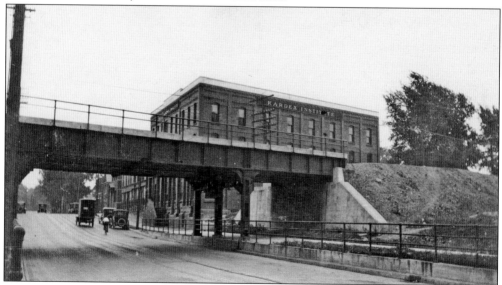

Kardex Institute, a division of Remington Rand, loomed above the New York Central Railroad Bridge on Goundry Street in the 1920s. The company manufactured record maintenance and inventory control products, which were housed in fireproof, freestanding units for all types of businesses. The Kardex Visible Record Control System is considered by many to be the precursor to the computer.

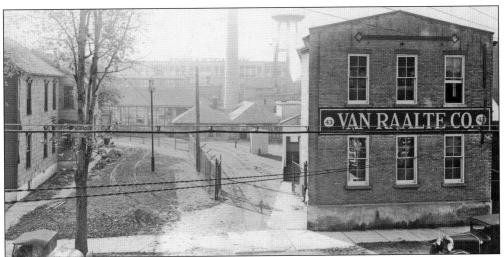

The Van Raalte Company, formerly Niagara Silk Mills, was a North Tonawanda landmark along the canal. For 65 years, the plant produced ladies undergarments, nightgowns, gloves, and hosiery. The facility closed in 1963 to make way for the Downtowner Motor Inn. Most recently, it has been converted into the Packett Inn Apartments.

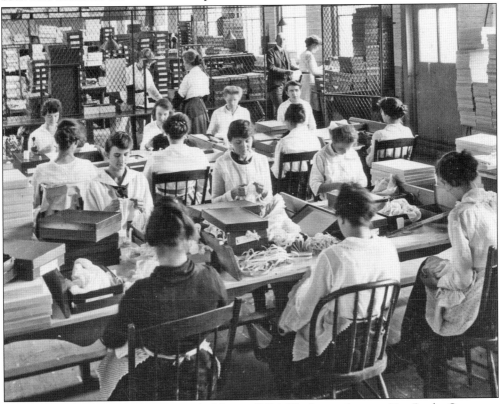

Pictured above are garment inspectors for Niagara Silk Mills, later to become Van Raalte Company. In 1907, a third story was added, which greatly increased the capacity of the plant. At peak production in 1955, employment reached 250. Operations were gradually moved to Saratoga, New York.

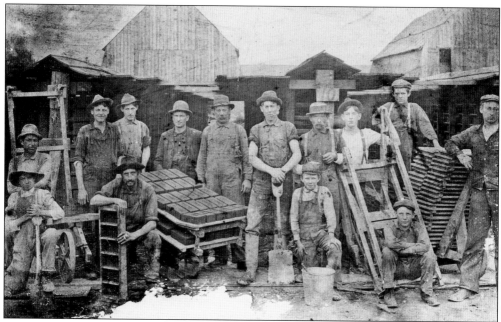

The employees of M. Riesterer and Son Brick Yard posed with their tools and product in this late 1800s photograph. Making bricks was labor-intensive and backbreaking work. Note the left side of the photograph where a worker is resting his arm on a six-cavity mold, next to a barrow of bricks. The brickyard was located on Delaware Street, near the state ditch.

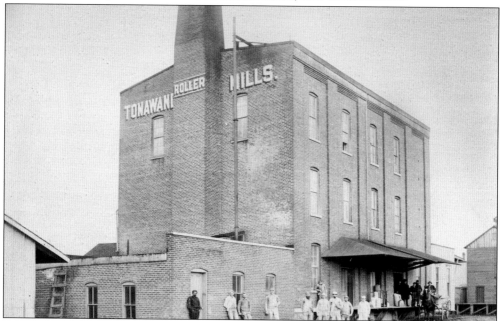

In 1863, C. C. Grove and L. D. Ebersole erected and equipped the Tonawanda Roller Mills, a four-story brick building at Mechanic and Oliver Streets in North Tonawanda. The plant processed spring wheat from Duluth, Minnesota, and winter wheat from Erie and Niagara Counties. It produced more than 200 barrels of flour per day with much of the product shipped to cities on the East Coast.

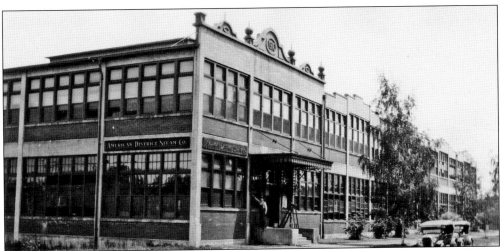

American District Steam Company moved to North Tonawanda in 1910. It manufactured steam heating equipment of every description until the late 1940s. In those days, steam was produced and sent through pipelines to homes, schools, businesses, and factories just as gas is today. In addition to this facility, there was also a main plant on Bryant Street north of Robinson Street.

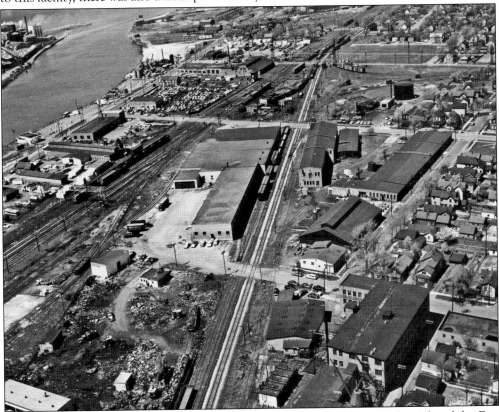

Auto Wheel Coaster Company occupied most of the larger buildings to the right of the Erie Railroad tracks, looking northwest over Schenck (foreground) and Robinson Streets. Lawless Container Corporation occupies the large building to the left of the tracks. The meeting of the tip of Tonawanda Island, the Little River, and the Niagara can be seen in the upper left corner.

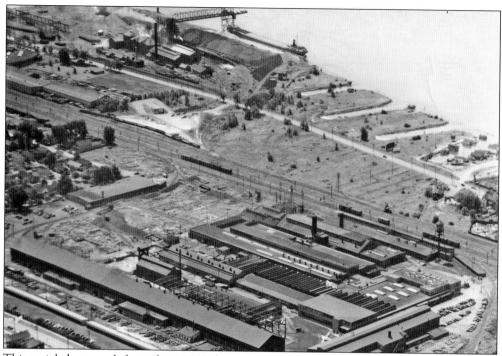

This aerial photograph from about 1940 shows the expansive Buffalo Bolt facilities at the corner of Oliver Street and East Avenue in North Tonawanda. The New York Central and Erie Railroad tracks run across the center of the photograph. Buffalo Pumps, Inc., a separate company, is situated just to the north of East Avenue at the lower center of the photograph. The Tonawanda Iron Corporation, located in the upper left corner, is in full operation.

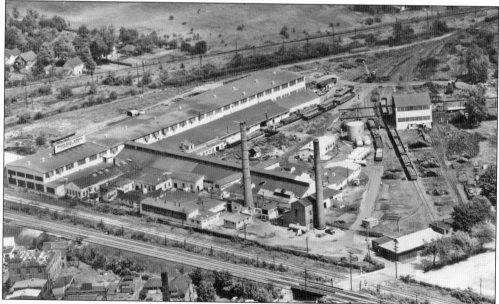

Founded in 1899, Buffalo Steel occupied a 20-acre site on Fillmore Avenue in the city of Tonawanda for over 60 years. They employed 400 workers in the fabrication of steel posts, bar, and so on. This image was taken in 1956. The New York State Barge Canal is in the background.

Four

OUT AND ABOUT

As with all 19th-century communities, transportation was an extremely important element in the growth of the twin cities of Tonawanda and North Tonawanda. While the construction of the Erie Canal opened the area to the opportunities afforded by a constant flow of people and goods, it was not until the advent of the trolley at the end of the century that the ability of the citizens of the Twin Cities to move around easily and quickly became more pronounced.

Prior to the 1890s, the main modes of local transportation were on foot or horseback; by wagon, carriage, or boat; on a bicycle; or by train. The latter, which ran through the heart of the business district, was generally used to come and go to other, larger communities or distant business and vacation destinations that required a rapid form of long-distance transportation.

In the early 20th century, the Tonawandas, like many communities, began to experience the major changes associated with the advent of the automobile. Within three decades, personal transportation became increasingly mechanized. With the greater flexibility of motor transportation came increased travel between neighborhoods and to the downtown area.

Because of the automobile, numerous businesses were opened and flourished in the Tonawandas, including auto dealers, gasoline and service stations, and wholesalers and dealers in tires, batteries, and automotive parts. By the end of World War I, the local trolley system was already experiencing competition from automobiles, and even local rail transportation was on the wane by the later years of the Great Depression.

In the period after World War II, downtown Tonawanda and North Tonawanda approached their peak as vital business districts, with cars, trucks, and busses providing transportation from every corner of the community. It was this increase in traffic, and the congestion that came with it, that stimulated the planning for the Seymour Street–River Road Arterial that would ultimately contribute to major changes in local transportation patterns.

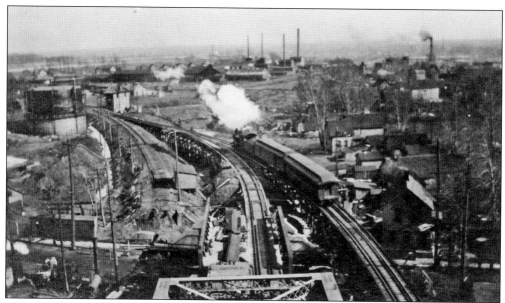

This photograph, looking south into Gastown from the top level of the new lift bridge being built over the Barge Canal, shows how the New York Central was able to accommodate the movement of trains on its Tonawanda Branch during the track realignment project between 1917 and 1922. East Niagara Street is shown in the foreground, and the stacks from Buffalo Steel are near the horizon.

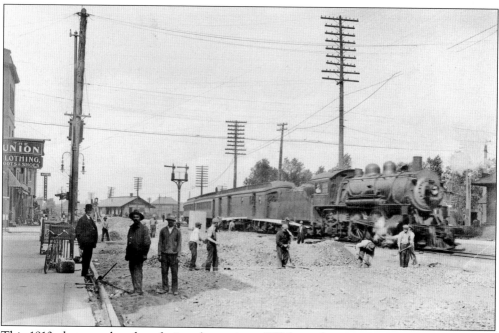

This 1913 photograph, taken during the paving of Webster Street, is an excellent example of the coexistence of trains and people in the downtown area. Note that the men working on the paving project seem undisturbed by the locomotive and passenger train heading south towards Tonawanda after pulling away from the North Tonawanda station in the background. At one point, more than 90 trains per day traveled through the heart of the Twin Cities.

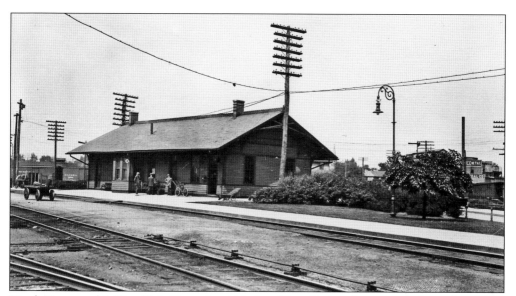

North Tonawanda's New York Central and Hudson River Railroad station was located on Main Street, just north of Webster, and served the community until the end of passenger service. The structure was demolished in June 1961.

The New York Central station on Main Street, near Fletcher, was built in the late 1880s. This station, located on the south side of the Erie Canal, served patrons riding the trains from Buffalo to the village of Tonawanda until 1919, when the tracks were removed from the downtown area. The building later served as Tonawanda's Public Library and is now home to the Historical Society of the Tonawandas.

The Twin Cities' track relocation project eliminated a number of dangerous grade crossings and opened up the downtown business districts to new development. Flagman William Goddert is manning his post in front of the crossing shanty at the corner of Main and Johnson Streets in the city of Tonawanda. With the opening of the bypass, flagmen at crossings would no longer be necessary.

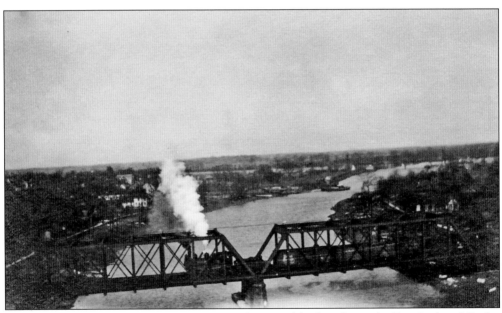

This view, taken from the top of the New York Central bridge, shows the Erie Railroad Bridge across Tonawanda Creek and the Erie Canal. While the Suspension Bridge and Erie Junction Railroad was constructed in 1870 as a rail line between Buffalo and Suspension Bridge near Niagara Falls, the railroad was immediately leased to the Erie Railroad and became known as its Niagara Falls Branch. The bridge was dismantled in 1990.

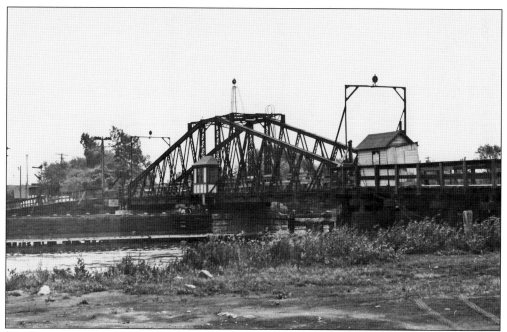

The Tonawanda Island Bridge Company constructed the Island Bridge in 1886 for the New York Central and Hudson River Railroad. The bridge acquired some fame during the lumber shovers strike as the point where the militia met the strikers. The Island Bridge provided rail and vehicular service to Tonawanda Island until June 1965. It was replaced with a modern structure, the Durkee Memorial Bridge, which was dedicated on November 1, 1967.

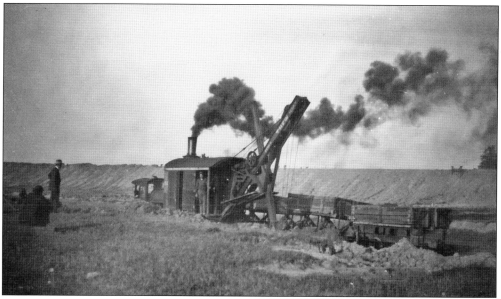

The 1917 to 1922 construction of the New York Central track elevation through Tonawanda necessitated the movement of more than a half-million cubic feet of fill. Temporary tracks were constructed to allow small donkey engines with side dump cars access between the clay pits behind the Spaulding Fibre Company property on Wheeler Street to the construction area between Ellicott Creek and Franklin Street. A steam shovel is loading the cars.

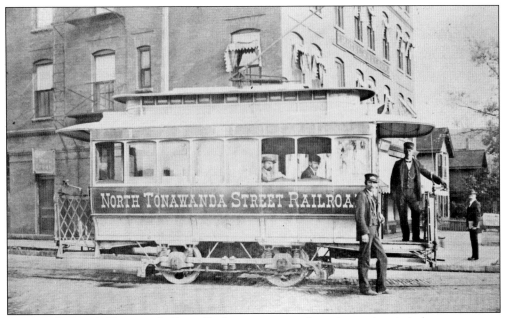

In 1893, the North Tonawanda Street Railway inaugurated service to the city's downtown area. The railway's first car is shown here at the Hotel Sheldon, located on the corner of Main and Goundry Streets. One of the area's most prominent luxury hotels, the Sheldon catered to lumber barons visiting the Twin Cities on business. The structure was destroyed by fire on November 12, 1940.

The Buffalo and Niagara Falls Railway No. 4001 makes the turn from Minerva Street onto William Street in Tonawanda in 1920. From its inception in 1897 until being abandoned in 1926, the "Falls Line" provided service between Buffalo and Niagara Falls. In 1895, the company built a brick powerhouse and trolley barn on Sweeney Street, but sold it in favor of a Gratwick carbarn at Warner Avenue and Boston Street in North Tonawanda.

A conductor and motorman pose in front of their trolley during reconstruction of the Buffalo and Niagara Falls Railway tracks on Delaware Street in the city of Tonawanda. The towers of the Tonawanda National Guard Armory are in the background. During the 1920s, Mary Maul's grocery store, Florence Bennett's confectionery and notions shop, and upstairs apartments were in the structure at the left.

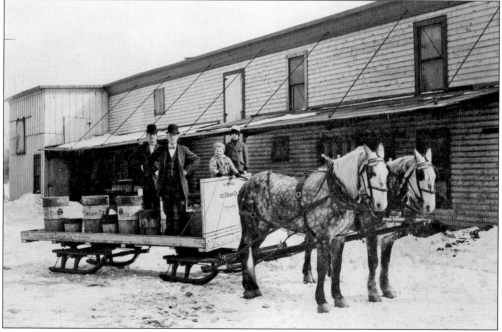

The National Ice Cream Company was located at 61 Fillmore Avenue in Gastown. In this photograph, taken about 1909, Samuel W. Thompson, manager of the company, poses on a company work sled with his two sons, Lloyd (at the reins) and Earl.

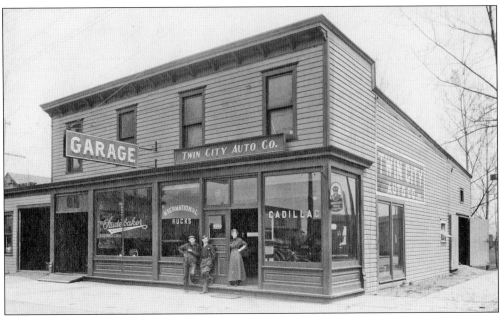

Around 1910, Walter Arenz established Twin City Motors on the east side of Main Street, between Tremont and Goundry Streets in North Tonawanda. Over the next half century, the business would represent Studebaker, Cadillac, and Buick automobiles and International trucks. After World War II, Roy Arenz Motors sold Cadillac and Pontiac, that is until Justice Pontiac took over the location in 1955, later becoming Keyser Pontiac in the early 1960s.

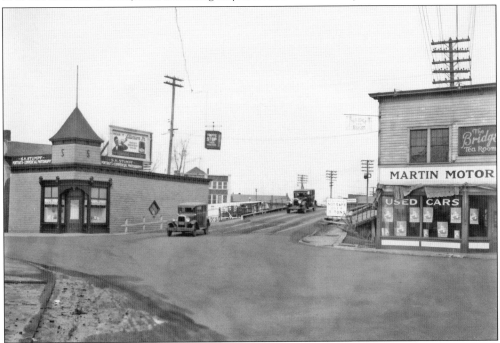

Two late-1920s vintage automobiles make their way over the Delaware Street Bridge ramp towards Young Street. Stumpf's Photographic Studio is on the left. Martin Motor Sales and the Bridge Tea Room on the right faced Young Street and backed up against Ellicott Creek.

Claude Smith's Service Station was located at Payne Avenue and Sweeney Street in North Tonawanda. The house that formerly stood on the site can be seen in the background. Smith took up residence there after moving it to provide room for his service station. Sandstone blocks from the original cellar of that house were used to face the new service station building.

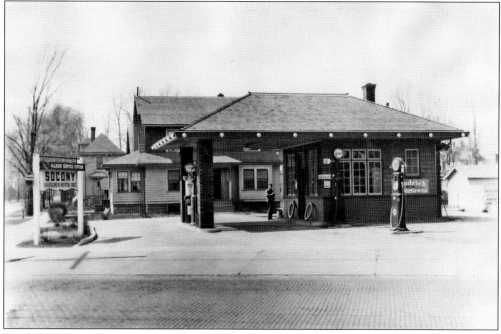

Frank I Alliger Jr. operated this gasoline service station at the corner of Main and Hill Streets in the city of Tonawanda. Opened in 1927, Frank sold Socony gasoline and lubricating oil and Goodrich automobile tires—the top brand in the country at the time—until his retirement in the late 1940s.

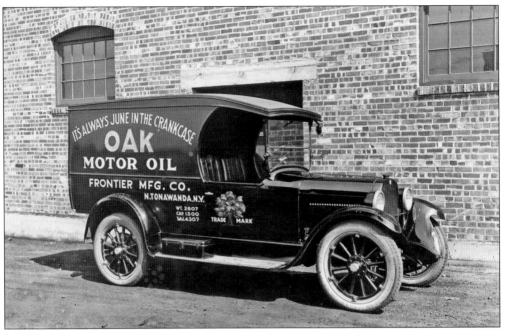

The Frontier Manufacturing Company was located on Erie Avenue in North Tonawanda and specialized in Top Cutting Oil and manufactured Oak Motor Oil. The company was founded by Stanley Peuchen of Goundry Street in North Tonawanda. An interesting note is that his brother, Maj. Arthur Godfrey Peuchen of Toronto, was a survivor of the Titanic disaster.

It is hard to imagine that this is the intersection of Division Street (foreground) and Erie Avenue in North Tonawanda. At the far right is Ernest J. Hurtubise's Service Station. The photograph was probably taken in the early 1940s from the old high-speed line tracks. The Twin City Arterial now utilizes the old right-of-way of the International Railway Company (IRC) high-speed line.

It was a rough ride down River Road in North Tonawanda in April 1956. River Road was still known as Main Street and did not extend to Niagara Street in Tonawanda until the Seymour Street Bridge was built. Wulf Bottling Works, River Road Lumber, Georgian Bay Lumber, and the North Tonawanda City Garage line the street. The Tonawanda Iron Works trestle is in the distance at the left.

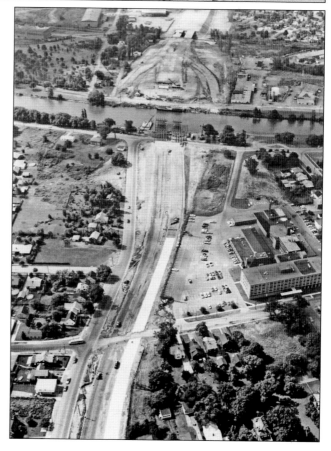

This photograph from July 1969 shows the construction of the Young-Division Arterial Bridge, later the Twin Cities Arterial, over the canal. DeGraff Hospital is clearly visible at right. The arterial's right-of-way coincides with the eastern edge of the 1-mile-wide New York Mile Strip Reserve, which ran alongside the entire length of the Niagara River. The high-speed line of the IRC had previously used this same right-of-way.

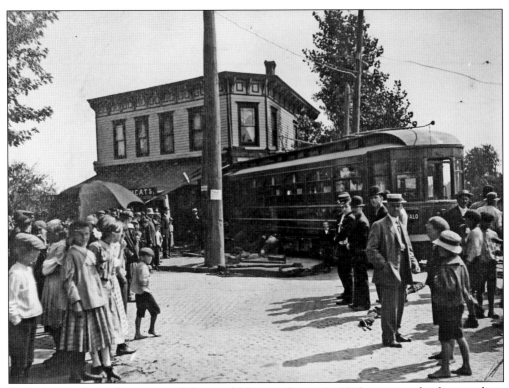

Onlookers gather at the corner of Main and Minerva Streets in 1916 to survey the damage done to Frank Holka's Meat Market when a trolley jumped the tracks and crashed into the side of the building. Earlier in the year, another trolley, operated by a new driver, failed to reduce the vehicle's speed when navigating a nearby curve and crashed into the store, wiping out the front of the building.

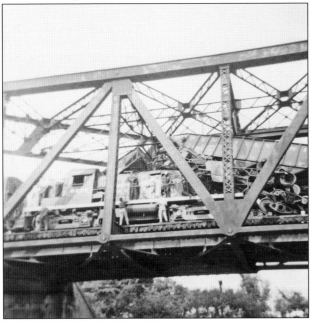

Hundreds of people lined the shore to watch rescue and salvage operations following the collision of a New York Central freight train with a caboose and empty coal cars on a trestle over Ellicott Creek in Tonawanda. The caboose split into pieces that hung off the bridge, and a coal car jackknifed into a semi-upright position on the bridge. Two crewmen were killed and five were injured in the 1962 accident.

Five

A GROWING COMMUNITY

With the emergence of so many industries in the area, employment became easy to find, and people poured into the Tonawandas in search of a new place to live and work. Most of these new residents were German immigrants. With the influx of new residents came the need to accommodate their needs—clothiers and tailors, groceries and grocers, eateries and cooks, banks and bankers, bakeries and bakers, dress shops and seamstresses, tonsorial studios and barbers, hat shops and milliners, schools and teachers, furniture shops and cabinet makers, drinking establishments and saloon keepers, livery stables and blacksmiths, disorderly houses and madams, trolley cars and motormen, paved roads and brick makers, smoke shops and tobacconists, apothecary shops and druggists, emporiums and proprietors, dairies and milkmen, hospitals and doctors, cemeteries and morticians, and churches and ministers. The collection of businesses and homes centered around the canal rapidly grew outwards.

The villages' dirt roads were suddenly kicking up too much dust from too many wagons and carts. Major streets were soon paved with brick to accommodate the increased traffic. A community where the village council had once scheduled its next meeting at "first light" on Tuesday next, now installed gas lamps, and later state-of-the-art electric lamps, to allow safe movement along the streets after dark. Numerous electric railway or trolley franchises were given permission to operate cars in the villages. The population exploded in the 1880s, and house construction could not keep up with the demand. Residential neighborhoods, with names like Ironton, Gratwick, and Delawanda, arose farther and farther from the canal.

New business districts emerged far from the old center of town. Tonawanda quickly reached its corporate boundaries with nowhere else to expand. North Tonawanda would grow much larger due to the greater landmass within its boundaries.

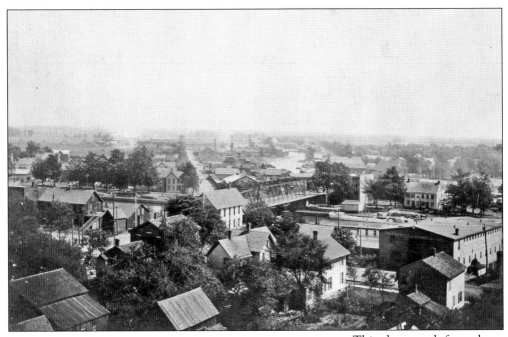

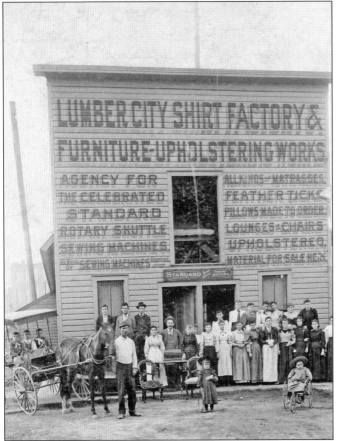

This photograph from about 1895 was taken looking southeast from the top of the six-story Smith Building in North Tonawanda. The canal traverses across the center of the photograph, with the Gastown section of Tonawanda visible on the far side. The Delaware Street Bridge is located at center with the Long Homestead off to its right.

The Lumber City Shirt Factory and Furniture-Upholstering Works had its home at 46 Broad Street in Tonawanda when this photograph was taken on August 24, 1892. The staff members are proud to show off a number of their wares, including a sewing machine and two upholstered chairs. Note the two girls up front. One of the girls has a hoop, while the other one is sitting on her tricycle.

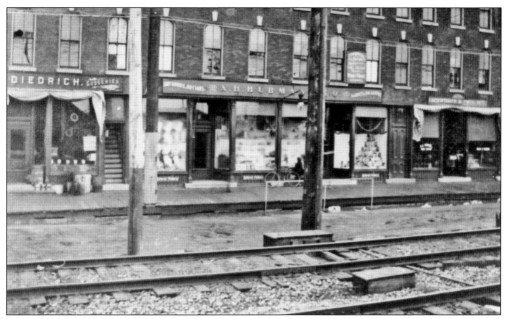

This is one of the few photographs showing the New York Central Railroad tracks running down the east side of Main Street in Tonawanda. The time frame is approximately between 1910 and 1915. Note the plank sidewalks providing raised, dry access to the storefronts of Diedrich's Grocery and Hubman's Dry Goods, located between South Niagara and Adam Streets. The building would later house Jenss Twin-Ton.

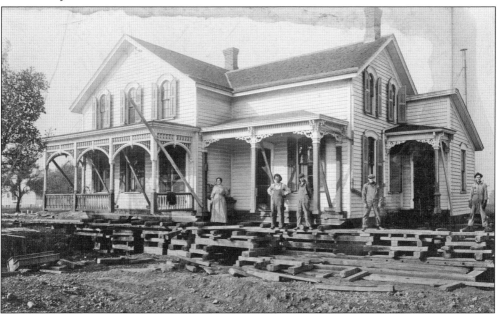

It was not an uncommon feat in the late 19th and early 20th centuries to pick up and move houses, churches, and other buildings. In the 1920s, the Schell family had their home moved one block north, from 464 to 448 Delaware Street. Frank Geltz was the moving contractor. Three generations of the Geltz family were involved in raising and moving buildings, boilers, safes, and other items.

Zuckmaier Brothers Department Store was a mainstay in the vast array of stores found in the Tonawandas' downtown district. Its prime location at the intersection of Main Street and Canal Street (now Niagara Street) in Tonawanda would later be home to the Jenss Twin-Ton department store. Here Zuckmaier's delivery wagon stands ready to serve one of its customers with a home delivery.

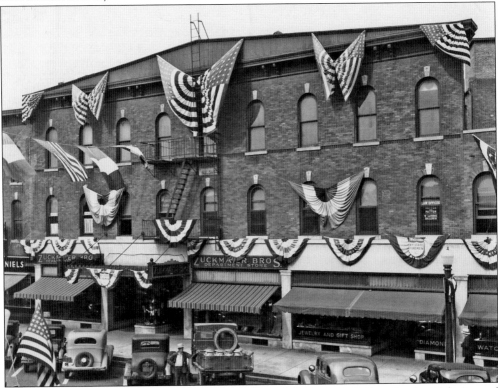

Businesses in the Twin Cities could not put up enough bunting and flags for the 64th Annual Convention of the Firemen's Association State of New York, which was held here in August 1936. This was the association's first convention held in Erie County since the Pan American Exposition in 1901. This photograph shows the Zuckmaier Brothers Department Store.

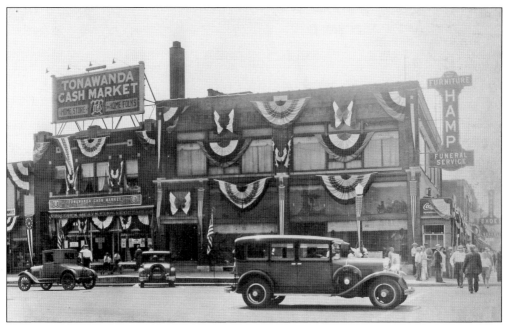

Hamp Furniture at 4 Young Street sold couches, bedroom suites, easy chairs, carpeting, and the like. Among Tonawanda's first morticians, owner Fred Hamp also provided embalming services and conducted funerals from the homes of the deceased. Located next door was the Tonawanda Cash Market. Strictly a cash-and-carry operation, the store featured a radio show on WKBW that featured Miss Gussie, who provided gossip and the entertainment news of the day.

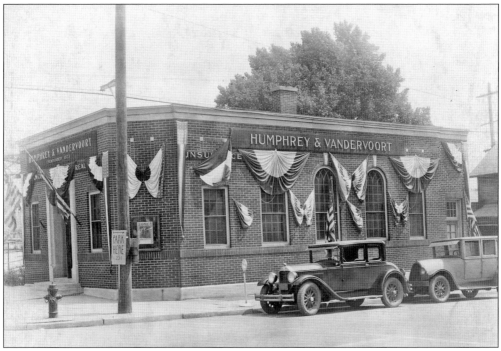

Humphrey and Vandervoort's new insurance office at the foot of Young Street in Tonawanda was all decked out for the firemen's convention in this 1936 photograph.

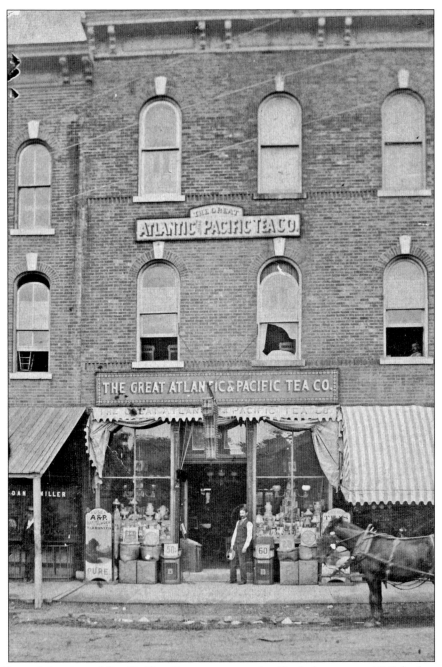

The Great Atlantic and Pacific Tea Company, more familiarly known as A&P, had gotten a foothold in the Tonawandas as early as 1886, when this photograph of its store at 10 Main Street in Tonawanda was taken. Known for its eye-catching displays, promotions, and premiums, A&P pioneered the concept of private labels and house brands, beginning with tea and coffee blends. In the 1920s, A&P introduced prepackaged meats, established food-testing labs, published money-saving tips and recipes, and printed *Woman's Day* magazine. Locally, A&P stores grew and declined with the chain's national trends. A&P operated stores at Broad Street in Tonawanda and Manhattan Street in North Tonawanda. A&P closed its last local store on April 26, 1975.

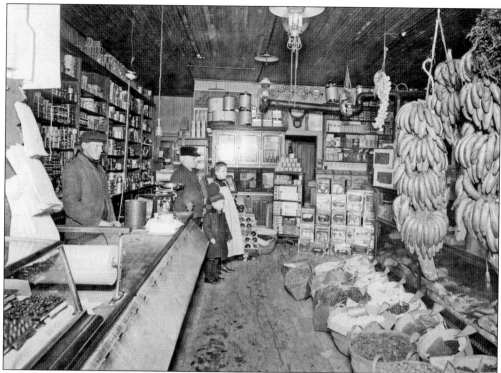

Yesteryear's grocery stores were a far cry from today's supermarkets with self-service checkouts, gift cards, debit and credit card purchases, and shopping carts with coffee cup holders. Bohlman's Grocery on Schenk Street (above) and Thiel's Grocery on Young Street (below) were typical of 1904 grocery stores. Clerks stood behind long counters and cut butter from tubs, sliced cheese from a wheel, scooped sugar and pickles from barrels, and sold penny candy from jars. A row of shelves behind the counter reached the ceiling, and items had to be captured with a long stick with a clamp at the end. Everything was weighed and put in bags or wrapped in paper. Two cans of Campbell's soup cost 25¢, a box of matches was 7¢, and a pork loin was 32¢ a pound.

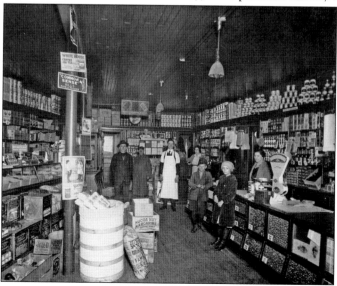

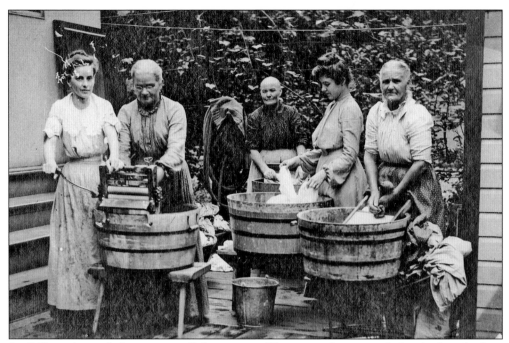

In 1899, washing clothes was an all-day project. Women made soap with lye, lard, and ashes. Clothes were soaked, scrubbed, boiled, rinsed, and blued in huge outdoor vats of water, put through a wringer, and hung out to dry on a backyard clothesline. Doing the wash at the home of Henry Rumbold at 26 Delaware Street are Mrs. Frank Rumbold, Mrs. Henry Rumbold, and Matie Rumbold, and their helpers.

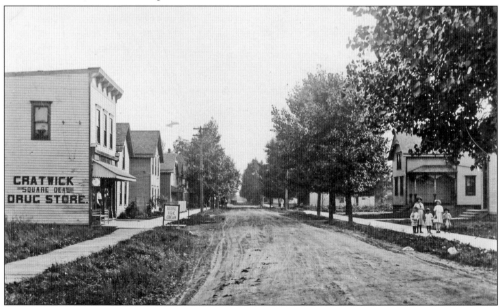

Around 1896, Walton Collette opened Collette's Drugstore on Felton Street in the Gratwick section of North Tonawanda. After his death in 1912, the drugstore was taken over by Fred Fairchild for several years before the building came down. The view is looking southwest from Oliver Street with the steps of the Third Presbyterian Church visible at the far right.

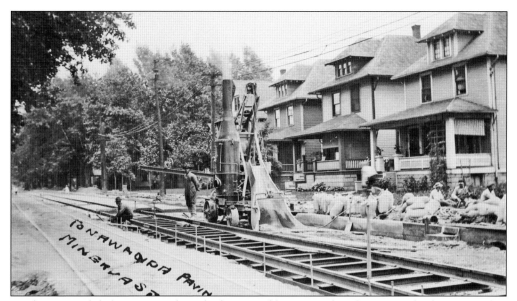

As the automobile began to replace the horse and buggy, road surfaces were slowly improved to accommodate them. Trolleys continued to be heavily utilized in the Tonawandas as well. Here in front of the homes at 87, 83, and 79 Minerva Street, paving is added alongside the trolley tracks in 1922.

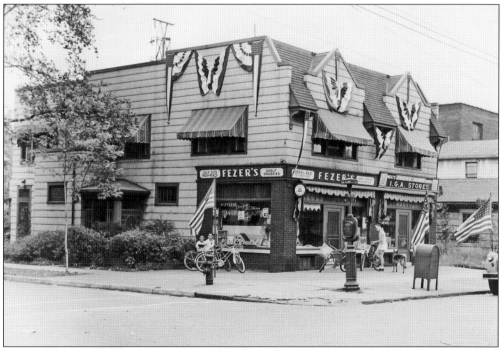

During the 1950s and 1960s, teenagers often rode their bicycles to the corner store to pick up something for mom or to purchase a pop or snack. One such stop was Fezer's IGA at 463–465 Payne Avenue. Opened in 1935 by Stephen and Magdelena Fezer, the store was family owned until it closed in 1978. Fezer's belonged to the Independent Grocers Association, which was set up for group advertising and mass purchasing for smaller stores.

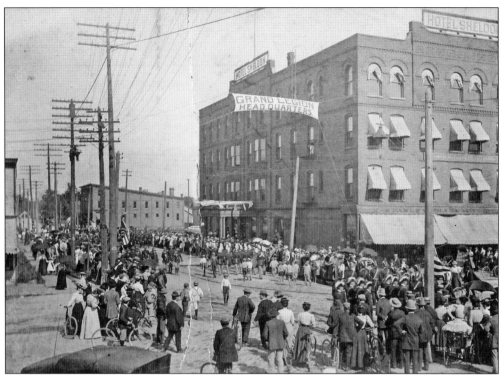

A crowd has gathered by foot and by bicycle at Goundry and Webster Streets, in front of the Hotel Sheldon, to watch a parade. The Hotel Sheldon dominated this corner for many years and was the site of many celebrations and civic and business events. Real estate developers held presentations at the hotel to attract prospective homeowners to purchase land or a home in a new Tonawanda development, Delawanda.

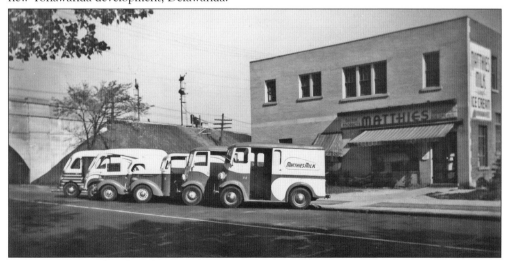

Milkmen delivered milk to homes early in the morning, placing bottled milk on the front step or in milk boxes. Milk boxes were either freestanding, galvanized steel, insulated boxes or were built into the walls of customers' houses. Originally established by Edward and John Matthies on Young Street in 1935, Matthies Dairy, pictured here with its fleet of delivery trucks, moved to 333 Delaware Street in 1938.

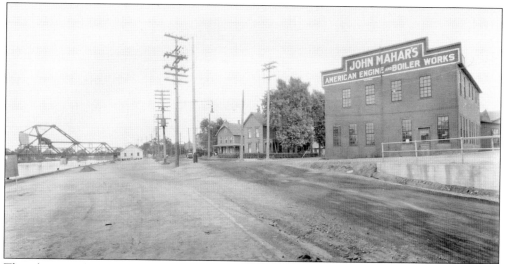

This photograph was taken standing on East Niagara Street, looking east at the railroad bridge. Fillmore Avenue is to the left of Mahar American Engine and Boiler Works, manufacturer of marine, stationary, and portable engines and boilers. Note the rope barn on the canal bank. A similar structure on the North Tonawanda side is now a favorite bar/restaurant among boaters—Dockside Inn.

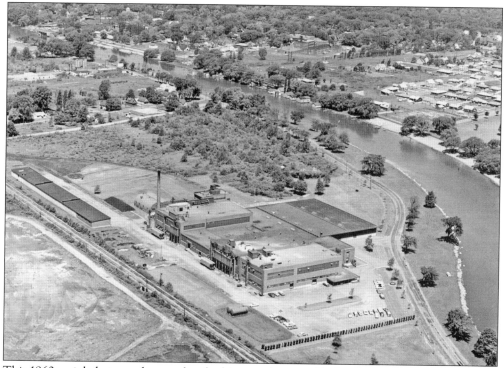

This 1960 aerial photograph was taken looking northwest at Exolon Corporation. Exolon moved to the city of Tonawanda in 1943, after fire destroyed its Blasdell plant. A fire-resistant facility on the south bank of the Barge Canal was constructed to manufacture abrasives such as silicon carbide and aluminum oxide, which were used for finishing glass, buffing and valve grinding, cutting and polishing stone, and as safety grit in floors.

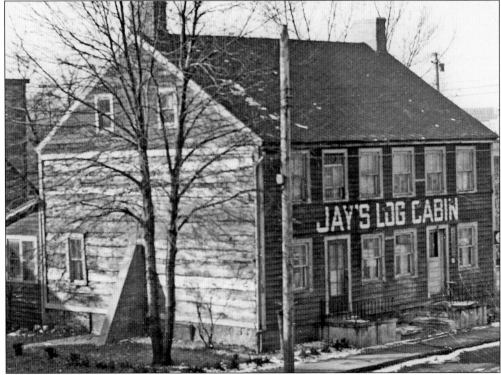

Jay's Log Cabin was actually a three-story log home. Built in 1829, the Long family lived there for about 30 years. Subsequently, the building served many purposes but was best known as Jay's Log Cabin, run by the Jared Tiffany family for many years, starting in 1943. A disastrous fire in 1971 almost destroyed the building. The Historical Society of the Tonawandas restored the house and opened it as a museum in 1979.

The Banas Saloon at 525 Fletcher Street operated from about 1905 to 1918. It then became a cigar store, a soft drink company, and later a hauling and trucking concern. Also known as Orchard Park, it was used for picnic and field day activities. The entrance was located to the left of the house, between two stone pillars. In the back was a large storage barn with a wooden dance floor.

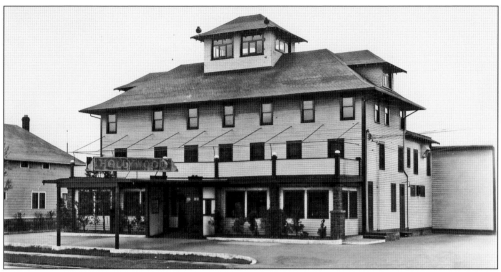

Built in 1919, the Hollywood, located at 643 Main Street in Tonawanda, was a fashionable hotel popular for wedding receptions and political and business meetings. It had a reputation as being a popular hangout for underworld figures from New York to Chicago. Spotlights were mounted on the cupola, which was where armed lookouts were said to have kept post. Nationally prominent dance bands, like Wayne King and Guy Lombardo, were featured there along with gambling.

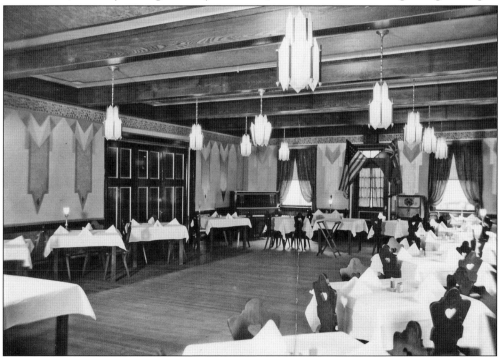

The Clay Pipe Room in the Delaware Hotel offered fine dining in the Tonawandas. The hotel, situated at 9 Delaware Street, was owned and operated by Michael Cutt. It could also be entered from Young Street because Delaware and Young Streets intersected at Broad Street, forming a triangle. The hotel had a good run under various names from 1929 until 1967, when it was razed as part of urban "removal."

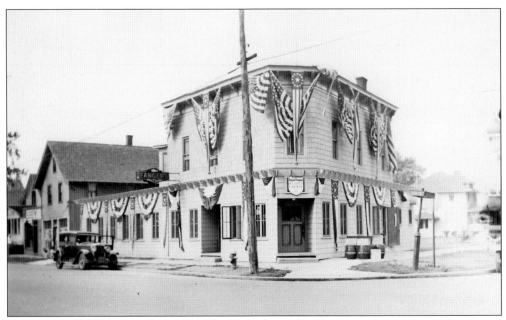

Fanger's Tavern was established in 1934 by Edward and Mae Fanger on the site of a barbershop at 200 Main Street. After Fangers moved to Niagara Street in 1956, the Double D set up business here until 1978. The site was then purchased by Rick Cassata, a former professional football player, a standout quarterback for Syracuse University and the Ottawa Roughriders, who operated it as the Dome Stadium.

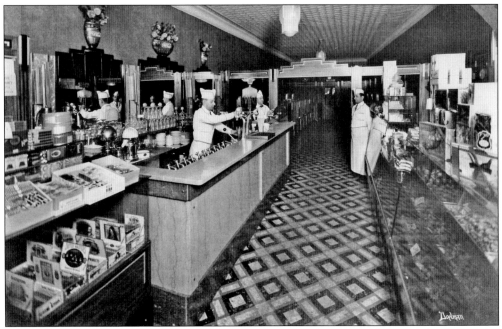

Tonawanda—not New Orleans—was the home of the original Sugar Bowl. Pictured is the interior of Zeffrey's Sugar Bowl in the late 1940s or early 1950s. The store operated from 1920 until 1972 at various locations. Shown here is the 5 South Niagara Street location, with co-owners Spiro and John Zeffrey. Prices included a hot fudge sundae at 15¢ and a chicken salad sandwich at 30¢.

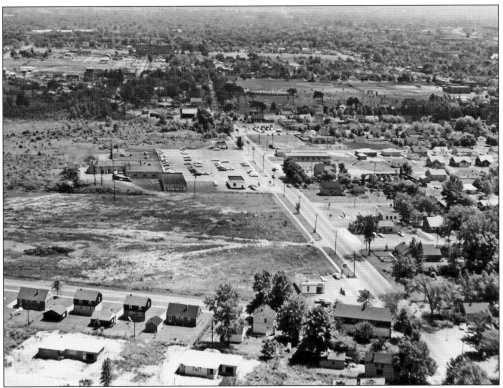

Above is the future site of Mid-City Plaza. Taken July 9, 1958, the photograph, looking south, shows the Payne Avenue Shopping Plaza at left, the old North Tonawanda High School and Memorial Pool in the distance, Gilmore Elementary School at the far right, and Meadow Drive in the foreground. The new Mid-City Plaza was under construction when the photograph below was taken looking north from Payne Avenue and East Avenue on February 4, 1960. The large building at the lower right is the former Park Manor Lanes, now the Salvation Army Thrift Store. The Klydel wetlands are near the top of the photograph. Tops and Sportsplex now occupy the open fields to the right.

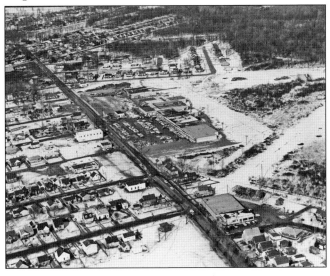

Located between Ward and Witmer Roads, the 1858 farmhouse (left center) in this 1896 photograph was the only residence ever built on the riverside of River Road within the North Tonawanda city limits. In the background is the top of the Gratwick carbarn of the Buffalo and Niagara Falls Electric Railway and the railway's Ely trestle. To the left is the old Edgewater Landing Hotel (later the Wa-Ha-Kie).

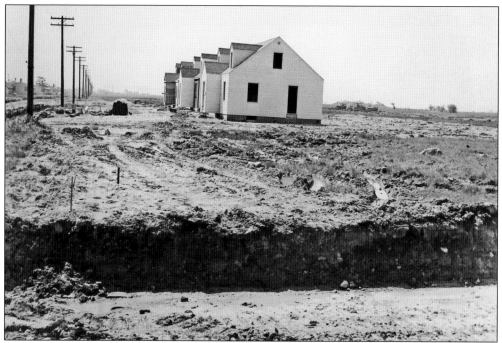

These are the first homes built in the Riverview Heights development in Tonawanda in the late 1940s. Hinds Street is at the far left, running south. The World War II veterans housing, visible in the distance at left, was razed to make room for the new Tonawanda Housing Authority project.

Looking north down Hinds Street in the late 1940s, the World War II veterans housing is still standing at the right. This was removed in the early 1960s to make room for the Tonawanda Housing Authority's new apartment buildings. At the left is the totally open field that would soon become the Riverview Heights development.

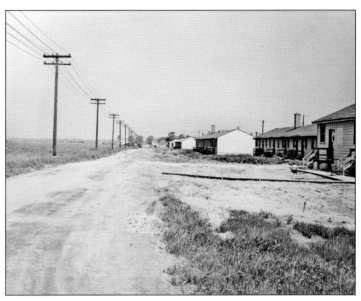

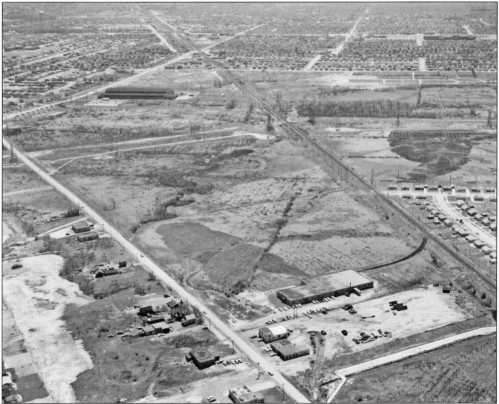

As late as the 1960s, this southeast corner of the city of Tonawanda retained its rural character. Today it is one of the city's busiest areas, encompassing the end of Young Street where it meets up with the Twin Cities Arterial and the Youngmann Expressway. Young Street is the predominant street, and Continental Can is in the distance, located on Colvin Boulevard. Cranbrook Road is at the far right. Today the Youngmann Expressway crosses over the center portion of this photograph.

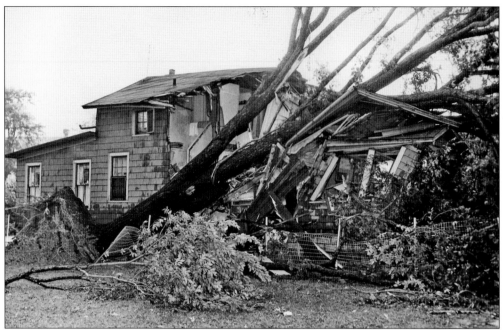

On July 1, 1953, one of the worst windstorms to ever hit the Tonawandas occurred. Winds that were clocked at 100 miles per hour sliced off trees, toppled utility poles, and left the city in a state of emergency. Pictured here is the home of Richard Garrity Sr. and the damage done to his home at 78 North Niagara Street.

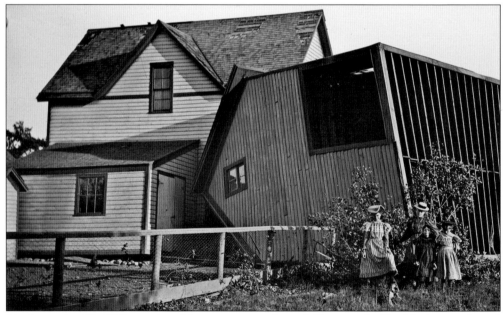

On September 26, 1898, a cyclone-like storm swept through Tonawanda. Two black cone-shaped clouds touched down on Adam, Morgan, Wheeler, Fuller, and Delaware Streets. Over 30 families were left homeless, and property damage topped $200,000. Houses and barns were wrenched from their foundations. Trees were uprooted, roofs ripped off houses, bricks flew through the air, and people who were outdoors when the storm hit were hurled against fences and buildings.

Six

BUILDING CHARACTER

The European immigrants that poured into the Tonawandas brought with them their varied cultures, religious beliefs, and languages. The church congregations that gathered weekly for Sunday services nurtured those traditions. While services in many churches were conducted in German or Polish, it was these same congregations that often helped immigrant families adapt to American life. Through various socials, sporting events, and entertainment programs, the churches provided a key part of the social fabric of the community.

While their primary function was to guide their membership in the ways of their faith, each congregation at some point would focus its efforts on the construction of an edifice. From within their memberships, skilled workers like stonemasons, carpenters, painters, musicians, and artists would proudly donate services to the building of these houses of worship. The result was a large assortment of church buildings throughout the two villages with steeples rising above the homes and businesses on both sides of the canal. In 1881, the newly completed steeple on St. Francis Church was the first to toll the news that Pres. James Garfield was dead. This was followed in turn by ringing throughout the community of one bell tower after another, thus alerting the residents that sad news was in the air. Many of the more impressive steeples were eventually lost to severe weather or age, including those of St. Francis, North Presbyterian, Ascension, and First Methodist. By 1910, there were over 25 churches in the Tonawandas.

In addition to the character formation provided by the churches and their parents, the children of the Tonawandas were instructed in the three R's, as well as manners, elocution, penmanship, and deportment within the public and private schools. Unfortunately, most children would have their formal education abbreviated so they could begin earning money to help support their families.

When it was established in 1852, the congregation of St. Francis of Assisi Roman Catholic parish extended well beyond the village of Tonawanda into the towns of Tonawanda, Wheatfield, and Amherst. In 1862, they constructed the stone edifice (below) that still stands on Adam Street today. The steeple was not added until the 1880s. Constantine Schimminger (left), a stonemason from southern Germany, settled in the village about 1852 and was one of two trustees for the new congregation.

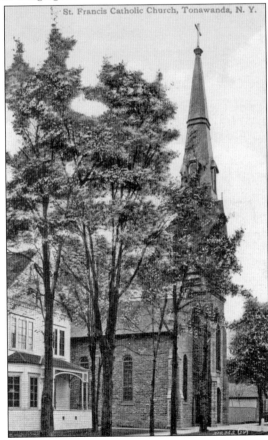

St. Francis Catholic Church, Tonawanda, N. Y.

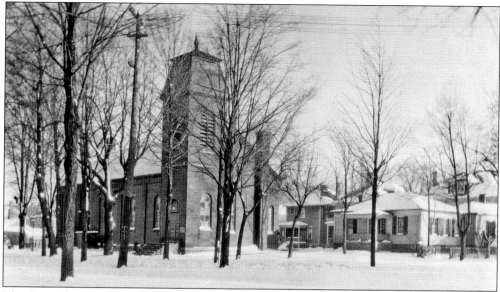

The former home of First Presbyterian Church of Tonawanda is no longer in existence. It was occupied from 1874 until 1963, when a newer building replaced it. The denomination was established in Tonawanda in 1852, sharing the Union Church building with three other Protestant churches until Col. Lewis Payne, Henry P. Smith, and Dr. Jesse Locke urged construction of the brick sanctuary near Clinton Park, shown in the photograph above.

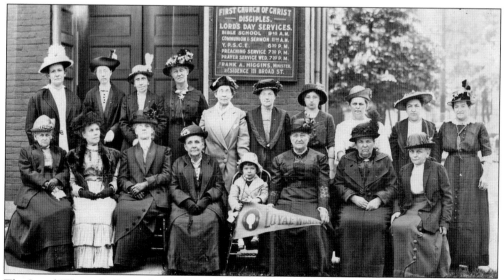

The Loyal Women's Group from First Church of Christ Disciples poses in front of their church building on the corner of Broad and Seymour Streets about 1915. The group depicted includes familiar local names like Mergandollar, Edwards, Gillie, Schwinger, Blessing, Maybee, Carpenter, and Creekmore.

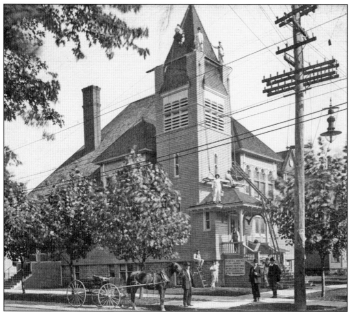

Now in disrepair, the Payne Avenue Church of Christ building was occupied from 1890 to 1961. This was one of few English-speaking churches in North Tonawanda. The church's name changed frequently due to abortive mergers with the Central Church of Christ. In 1961, the merger finally came to fruition after years of on-again, off-again efforts at unity. The church relocated to Wheatfield in 2004 and was renamed the Church at Shawnee Landing.

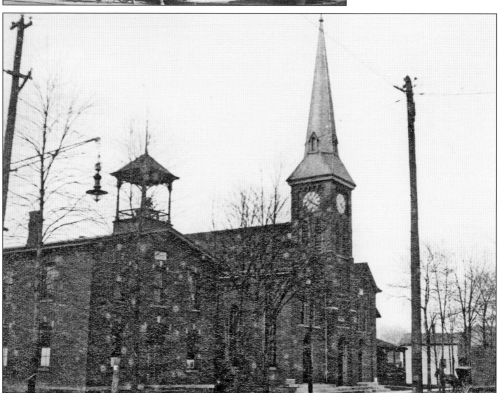

This is a view of Salem Church, now Salem United Church of Christ, on a wintry morning before 1900. The first frame building was constructed at Morgan and Main Streets in 1857. The present building was constructed around it and dedicated in 1889. Worship services were conducted entirely in German until 1906. The schoolhouse is the building with the tower. The clock was made in 1871 in Munich.

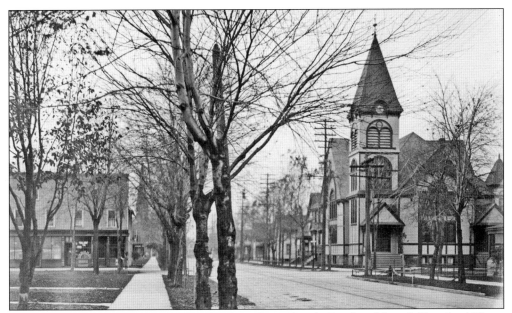

Originally the German United Evangelical Friedens Church, Friedens United Church of Christ was established in 1889, and its edifice was dedicated in 1890. The founders were members of Salem Evangelical Church, later the Salem United Church of Christ, in Tonawanda. The building is now the home of Ghostlight Theater.

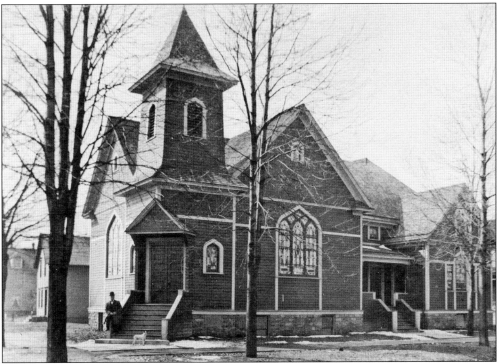

Grace Methodist Church, once located on Franklin Street, built this structure at the corner of Broad and Seymour Streets in 1903. Business leader James Rand was a leading member. It was razed in 1970 to accommodate an outlet of Thiele's Dairy, now also extinct.

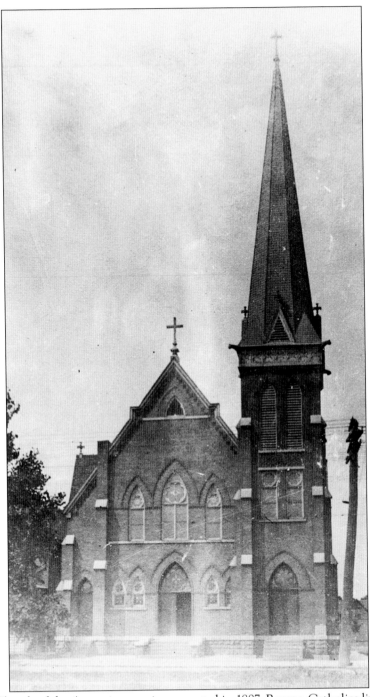

Until the Church of the Ascension was incorporated in 1887, Roman Catholics living north of the Erie Canal attended services in Tonawanda's St. Francis of Assisi Church. On the corner of Robinson and Vandervoort Streets in North Tonawanda, the first building of the Church of the Ascension was dedicated in 1888. Destroyed by fire on December 21, 1893, it was rebuilt in brick in 1894, as seen in this view. Lightning toppled the steeple in September 1913. The edifice is exactly the same today except for the truncated steeple.

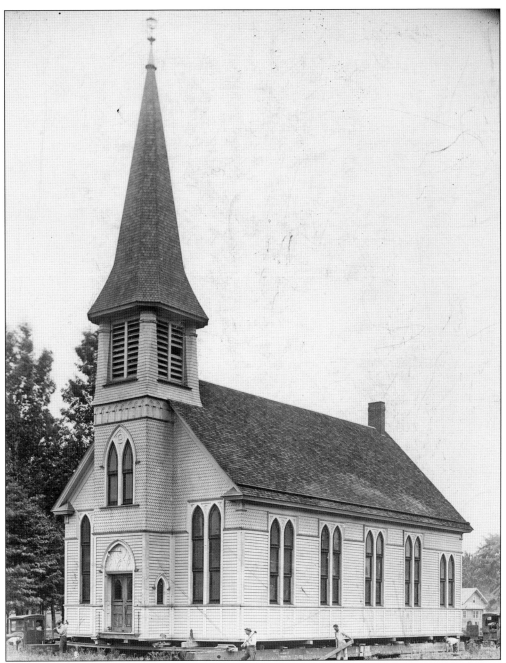

The "moving church," St. Paul's Evangelical Lutheran Church, was first moved up the block from its original location on Washington Street in North Tonawanda in 1891. The pictured church replaced it and was dedicated in 1895. The photograph shows another move in 1927, when the building was reversed to face East Felton Street. Services were conducted in German until 1920. The building's final move was to oblivion; it was razed in 1976.

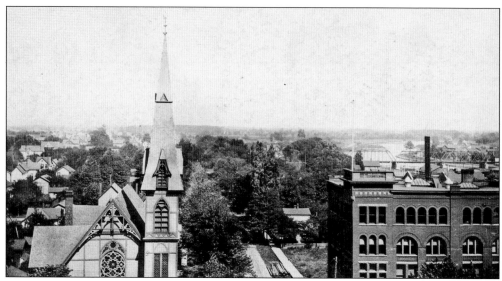

This photograph, taken from the top of the six-story Smith Building about 1895, clearly shows the original steeple of the First Methodist Episcopal Church, located on the corner of Main and Tremont Streets. The steeple blew down in a storm on April 7, 1909. The YMCA building, which also housed the North Tonawanda Police Department, is at the right. Tonawanda Creek can be seen in the distance, above the YMCA building.

Members of the confirmation class from St. Matthew's Lutheran Church in North Tonawanda, consisting of (from left to right) Alfred Holland, Frances Rhinebolt, Margaret Fritz, and Regina Proefrock, pose on April 1, 1917, with their pastor, the Rev. Carl Frankenstein (center). H. F. Wittkowsky provided the pastor's chair and religious backdrop that were used for the formal sitting at his photography studio.

Tonawanda's old brick Union School was built in 1866 on the southwest corner of the public square, known today as Clinton Park. It housed all of the village's elementary classes and, beginning in the 1890s, its first high school students. Destroyed by fire on December 26, 1896, a new building, Central School, was quickly rebuilt on the same lot. The photograph was probably taken in the mid-1880s.

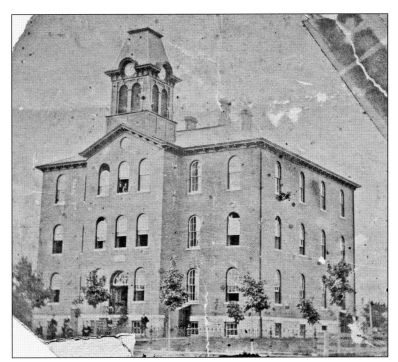

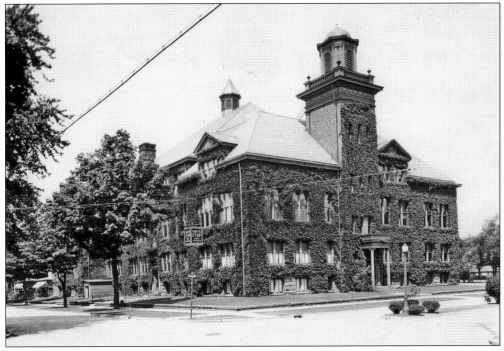

Ivy covered the walls of Central School by the time this photograph was taken. After the Tonawanda School District built Kibler High School in 1926, this building continued to house the lower grades of Central School, as well as a small public library. The third floor was removed in 1956. Today Central School is home to a number of special programs that are operated by of the Tonawanda Board of Education.

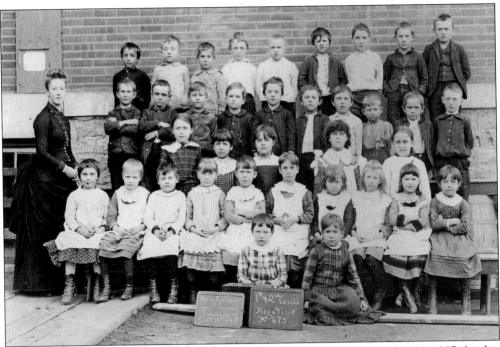

First and second graders of Tonawanda's Union Free School posed on October 18, 1887, for this photograph, which was taken on the school grounds adjacent to Clinton Park. This one main school building housed all grade levels on the south side until 1891, when another elementary school was constructed.

Pine Woods School No. 3 stood at the east end of Schenck Street in North Tonawanda. Built in 1892 at a cost of $20,000, the school remained open for over 80 years, closing in 1973. The building was razed in 1983. The photograph is from 1903.

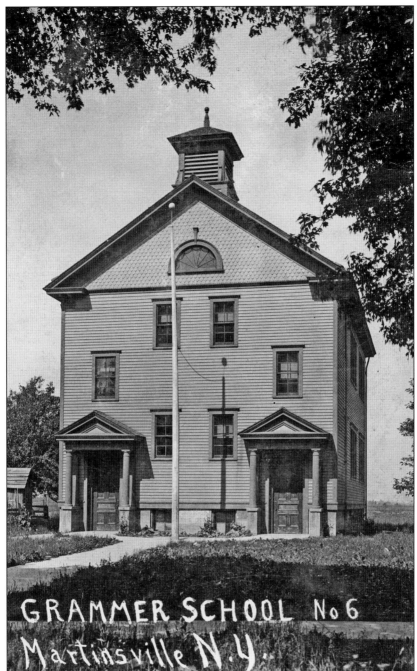

GRAMMER SCHOOL No 6
Martinsville N.Y.

In the first quarter of the 20th century, the children of Martinsville attended this early School No. 6. The school stood on Old Falls Boulevard, just south of Walck Road. Notice the separate entrances, one for the boys and one for the girls, popular in most schools of that era. Martinsville, which is the eastern section of North Tonawanda, was established on April 10, 1842, when a delegation of immigrants from Prussia came to the area and purchased 500 acres of land on the Tonawanda Creek from William Vandervoort. As soon as the people were settled, the hamlet was called Martinsville in honor of Martin Luther.

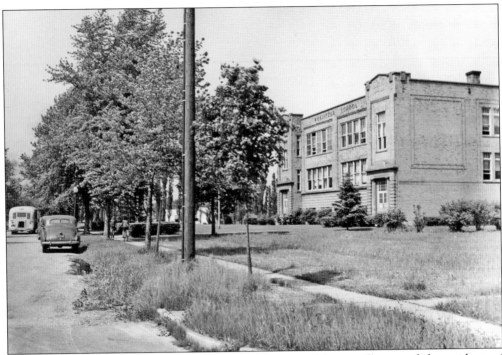

Wurlitzer School, located at Strad and Elwood Avenues in Martinsville, served the residents of that section of North Tonawanda from the late 1920s to 1976. When this photograph was taken in June 1947, the baby boom was getting ready to swell the ranks of schools across the Tonawandas. By the 1970s, enrollment had dropped significantly, and the school district closed the school, which later became a community center.

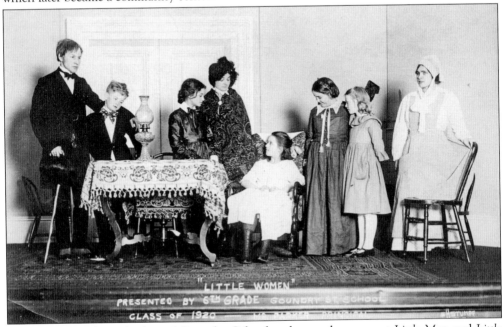

In 1920, the sixth grade class of Goundry School endeavored to present *Little Men* and *Little Women*. Here the costumed cast of the latter poses for the photographer.

Seven

HEART OF
THE COMMUNITY

As seen in the first chapter, the Erie Canal was the impetus for the early settlement at Tonawanda. As the population increased and homes were built, the "wilderness" was transformed into neighborhoods. Concurrently, businessmen, tradesmen, and professionals were attracted to the area to serve the needs of the growing community.

Since the Erie Canal passed through the middle of the town, it was not long before a well-defined downtown area evolved. Shaped somewhat like a spoked wheel, the downtown area connected North and South Canal Streets, Young Street, and Main Street and extended over the Long Bridge to Webster Street. Stores, shops, and professional offices lined the streets on both sides of the Erie Canal, and residents could purchase almost anything they needed right in town. Canal boat and freighter captains would also shop while in port to resupply their ships for the trip back home.

Downtown was more than just businesses; it included entertainment areas as well. The Hotel Sheldon, for example, catered to lumber barons and out-of-town visitors and hosted the finer social events of the day. At the other end of the spectrum, canalers, who were often paid when they arrived in port, were known to spend their earnings freely in the bars and brothels that were located on Goose Island. Of course, theaters, restaurants, and other venues offered activities for date nights and family outings.

By the 1920s, the canal was filled in, and the railroad rerouted away from the downtown. Times had changed; so did downtown. Pedestrian traffic remained heavy, but cars and trucks replaced horses and wagons. Business was still booming! When the canal was filled in, the area in the center of town became a landscaped circle. In time, "the circle" evolved into a popular, picturesque landmark that provided a panoramic view of downtown and became the home of the whistling traffic signal. The sights and sounds of a vibrant downtown continued into the 1960s.

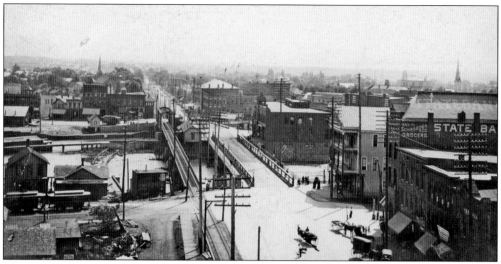

The view, looking south from the top of the Smith Building on Webster Street in North Tonawanda, commanded a spectacular view of the Tonawandas' downtown before the 20th century. Webster and Main Streets and the New York Central Railroad can be seen running parallel as they cross Tonawanda Creek and the Erie Canal. The steeples of Salem Church (left) and St. Francis Church (right) can be seen in the distance.

After the formal opening ceremony, Tonawandans strolled across the new Bascule Bridge over the Erie Canal. Completed in 1919, the bridge deck could be opened and raised to allow large vessels to pass. The Bascule Bridge replaced the Long Bridge, which was destroyed after several canal boats crashed into supports during a flood in 1917.

The deteriorating Erie Canal wall can be seen in the foreground of this photograph, taken in the mid-1920s. This photograph is looking north across the recently abandoned canal, toward North Canal Street and Goose Island. O'Connor's Ship Chandlery (later O'Connor's Toy Store) is at the far left. The Eagles have their rooms in the large three-story building, which sits where the HSBC drive-through tellers sit today, on Niagara Street in downtown Tonawanda.

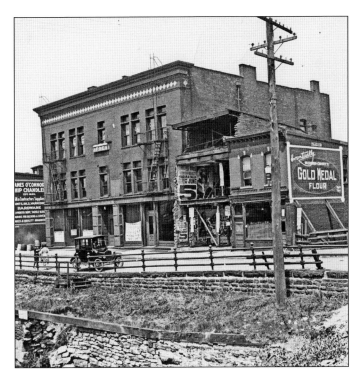

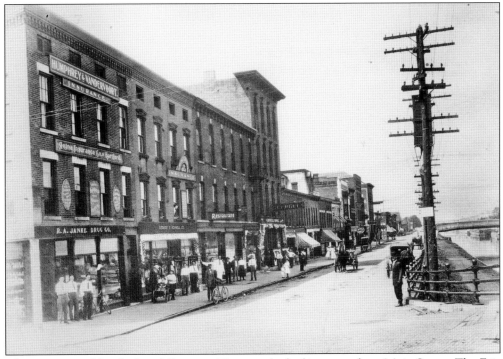

This is a view of South Canal Street in Tonawanda, looking west from Main Street. The Erie Canal is on the right with the Seymour Street Bridge over the canal in the distance. Humphrey and Vandervoort Insurance and Janke Drugs occupy the anchor location at the corner. The gentleman in the four-wheel cart at left is George E. Lewis, news dealer.

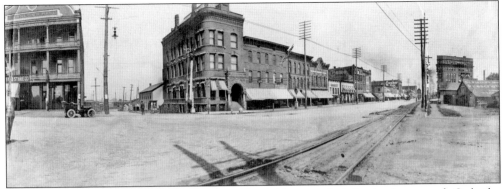

The Webster-Sweeney Street intersection in North Tonawanda is in the foreground. Only the third and fourth buildings down from the intersection stand today. The third building predates the Civil War and is now home to Crazy Jakes, a popular watering hole. Today this block houses a liquor store, bakery, a boutique, collectables, and an antique shop. The cornerstone on the fourth building, with the peaked roof, carries the date 1877. On the right of the tracks and a block away is the six-story Smith Building, also long gone.

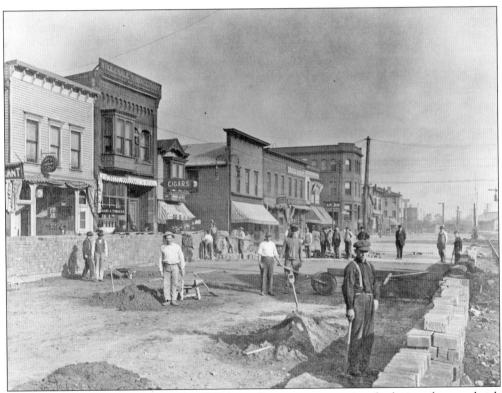

Bricks are piled high on either side of Webster Street in preparation for laying the new brick pavement on North Tonawanda's main thoroughfare in 1913. This photograph was taken between Tremont and Goundry Streets. Businesses that stood on the west side of Webster Street, opposite the New York Central Railroad tracks, included the White Elephant Café, Beltz Cigars and Tobacco, a liquor store, Janke Druggist, and the Union Clothing House.

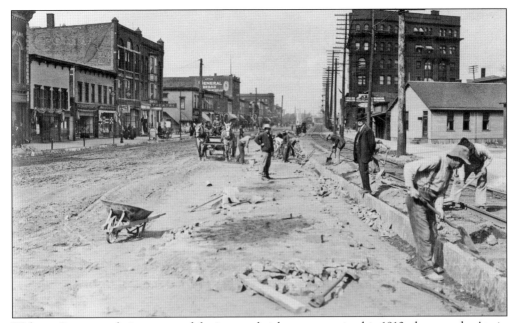

Webster Street was being prepared for its new brick pavement in this 1913 photograph. At six stories in height, the Lumber Exchange Building, at the right, towered above the Twin Cities from 1890 into the 1930s, when fire destroyed it. Storefronts along Webster Street's west side are still recognizable today. The east side of Webster Street changed drastically after the New York Central tracks were removed in the early 1920s.

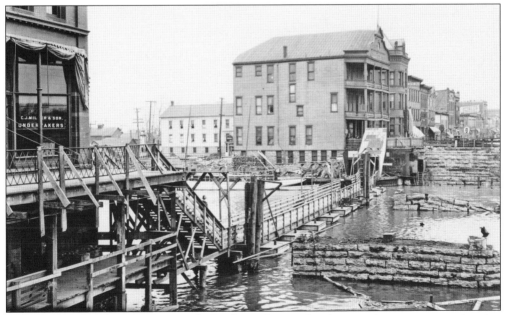

After the Long Bridge over Tonawanda Creek was damaged and removed, a temporary pedestrian pontoon bridge was built to facilitate travel between the Tonawandas. Later a temporary vehicular bridge was constructed to the left of the pontoon bridge, allowing limited traffic to cross at this location until the Bascule Bridge was built. The front porches of the Scanlon Building in North Tonawanda had to be removed to construct the temporary vehicular bridge.

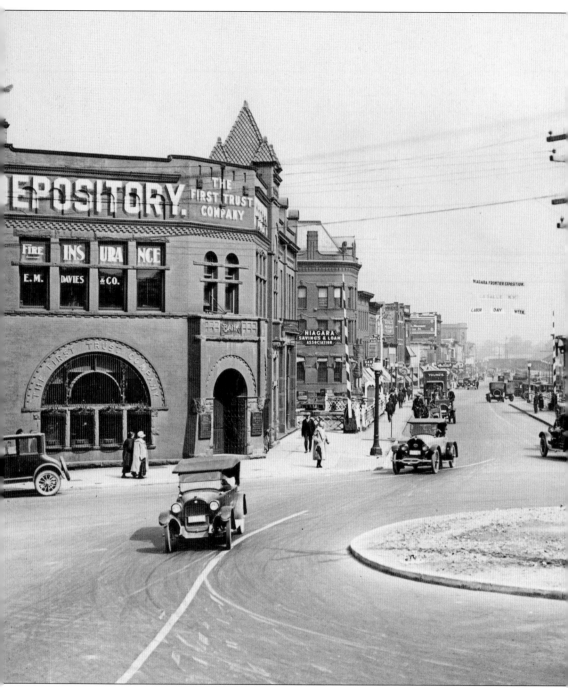

Tonawanda's "circle" joined the intersections of North, South, and East Niagara Streets, Young and Main Streets, and the Bascule Bridge. This 1924 photograph shows the First Trust Bank at the left, the Bascule Bridge in the center, and Webster Street in the distance. To the right of the

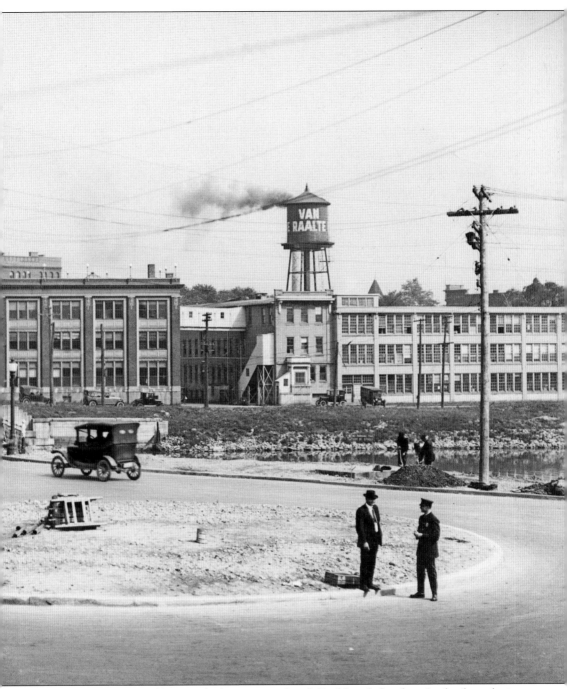

bridge is the Sweeney Building, with the six-story Smith Building behind it. At the far right is the VanRaalt Silk Mill.

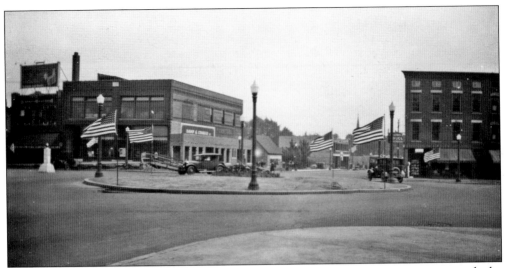

For many years, the "circle" in downtown Tonawanda was simply a large intersection with the whistling traffic light in its center. However, in this photograph, taken shortly after the Erie Canal bed was filled in, it can be seen that an actual circle did indeed grace the spot for a short time.

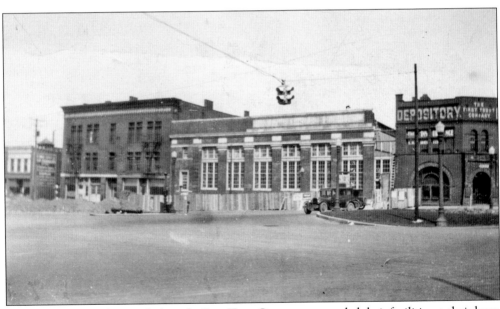

Business was never disrupted when the First Trust Company expanded their facilities at their long-established site on North Niagara Street at the foot of Main Street. The west end of their new building (later Marine Midland and HSBC banks) was completed before the original structure, the Depository, was razed and the east end of the new facility was constructed on the site. The completed facility opened in March 1929.

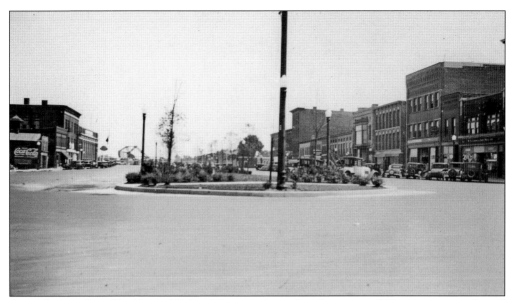

Once the Erie Canal had been filled in, Tonawanda tried to distance itself from its raucous "canal district" reputation. The downtown canal bed was replaced with a landscaped median. North and South Canal Streets, which had straddled the two sides of the canal, were renamed as North and South Niagara Streets. Of all the structures seen here, only the HSBC Bank Building at left and the jackknife bridge in the distance remain.

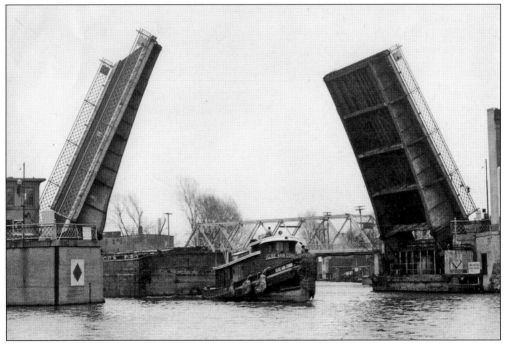

The tug *Elise Ann Connors*, with a barge in tow, passes the open bascule bridge in April 1955. The East Niagara Street Bridge over Ellicott Creek is directly behind the tug, and the top of the Palace Livery building can be seen behind the barge.

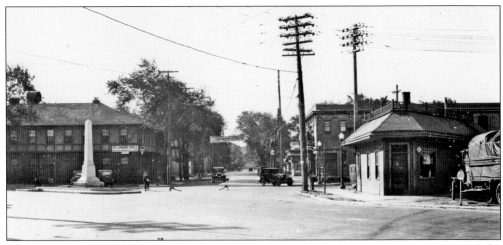

Little remains today of this view of the Delaware, Broad, and Young Streets intersection. The Delaware Grill at the left was lost to fire. The site is now a Burger King. A newsstand, formally a trolley waiting room, is on the right. Behind it is the Flash Theater, which is now the Bethesda Full Gospel Tabernacle. The Civil War monument at left was moved to Grove and Main Streets in Tonawanda.

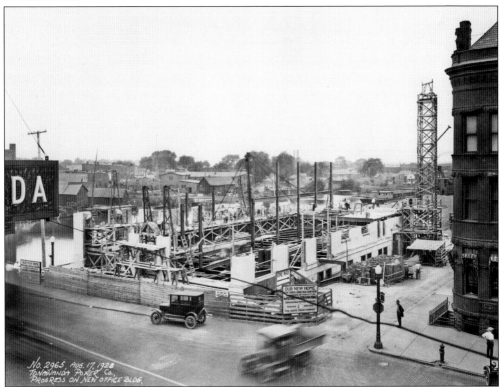

The Scanlon Building, a landmark of the Tonawandas, had long stood on this sight at the south end of Webster Street. In 1928, the Tonawanda Power Company constructed a new steel-framed building on the site, which is now the home of Suzuki Strings. Across the canal in the background are the homes and businesses of Goose Island. Near the center of the photograph Chestnut Street can be seen running into the distance.

On the corner of Goundry and Main Streets stood the impressive four-story, redbrick Hotel Sheldon, popular with lumber salesmen and bachelors who lived there. Built in 1890, the top floor housed a ballroom. The top floor also had a clubroom, which was where the Frontier Club met. The Frontier Club was composed of prominent local businessmen who gathered on Saturday nights to play cards. The photograph is from the 1930s.

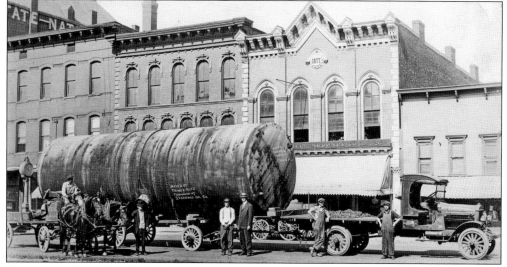

If one wanted anything large moved in the Tonawandas in the early 20th century, the person to call was Frank Geltz. Here in 1922, his crew is moving a large tank for the Standard Oil Company. The photograph was taken on Webster Street in front of the Cramer Hardware Store.

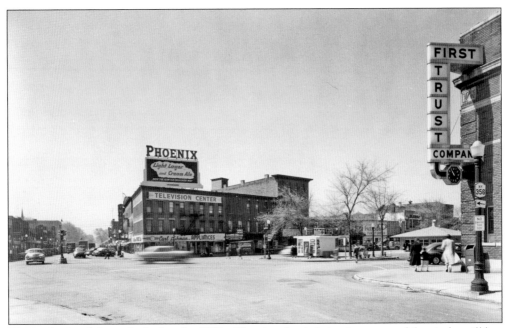

This is the "circle" as it looked in the 1950s. The signal at left, in the center of the circle, still has only two lights—red and green—meaning that it was still the whistling model, which gave an audible alarm when it was about to change. Twin-Ton is already situated on Main Street but has not established its anchor location on the corner of Niagara and Main Streets.

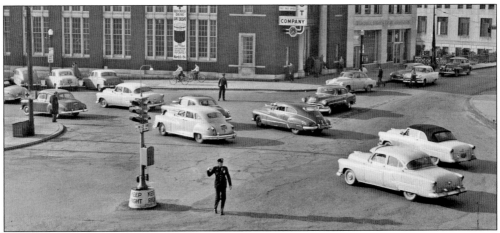

The busy intersection of North Niagara, South Niagara, East Niagara, Young, and Main Streets—constituting the "circle" in downtown Tonawanda—greets travelers coming off Webster Street and the Bascule Bridge at the upper right.

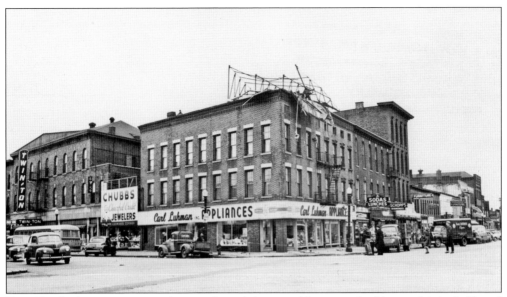

Twin-Ton had not yet procured ownership of the enviable corner building at Main (left) and South Niagara (right) Streets when this photograph was taken about 1950. This corner location, the anchor of the Tonawandas' shopping district for close to 100 years, housed multiple tenants beginning in the 1860s through the 1890s with Nice, Hinkey, and Company, followed by Stanley Drugs, Parsons Drugs, Luhman's Appliances, and Jenss Twin-Ton.

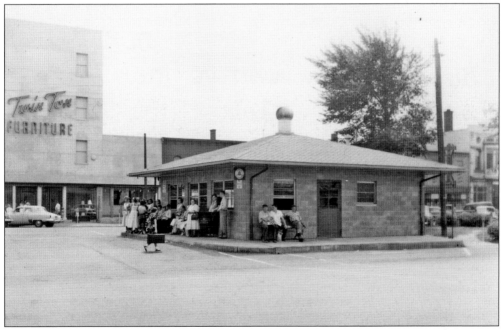

The bus station in Tonawanda sat between North and South Niagara Streets atop the filled-in Erie Canal bed. In the background, Twin-Ton had recently modernized the facade of the old Zuckmaier Department store on the corner of Main and Niagara Streets.

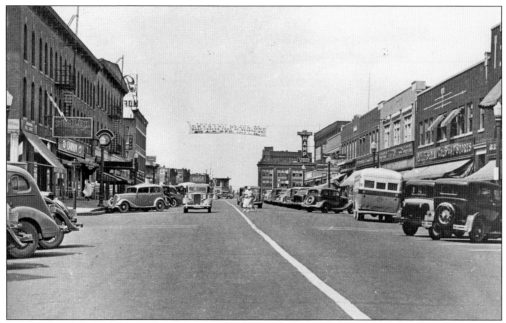

Here is Main Street, Tonawanda, in the 1930s. Stores in downtown Tonawanda and North Tonawanda provided almost everything shoppers needed in the early part of the 20th century. On this characteristically busy day, a banner strung across the street declares that Tonawanda's Day at Crystal Beach is at hand. A Carpenter bus is accommodating passengers on the right.

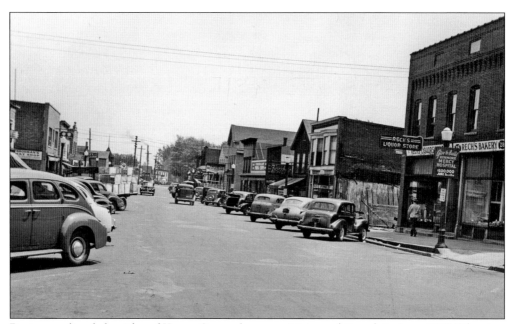

Businesses lined the sides of Young Street, between Main and Broad, in June 1947. The sign in front of Rech's Bakery is promoting a fund-raising drive for the construction of Kenmore Mercy Hospital.

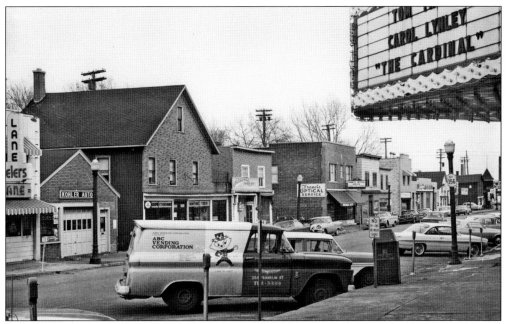

The northeast side of Young Street, between Main and Broad Streets, was still lined with storefronts and parking meters in March 1964. Lane Jewelers, Kohler Auto Glass, Patty Used Furniture, Francis Optical, Sentz Insurance Agency, Bergers Cleaners, and Eddie's Corner Delicatessen are pictured from left to right. The Star Theater marquee at right announces that *The Cardinal* is currently showing.

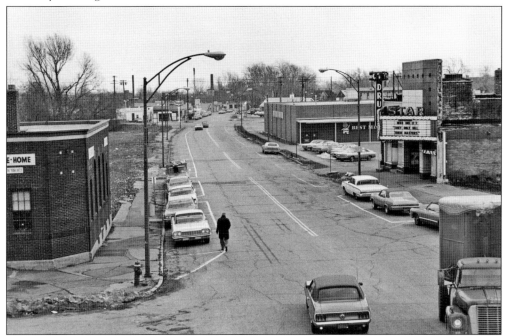

The Star Theater and Ott's Drugs are all that remain of the former businesses that lined Young Street a decade or so earlier. They too are about to come down. Loblaw's was one of the few new buildings constructed as part of urban renewal. It too is now gone.

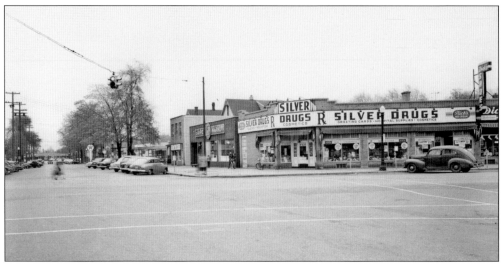

This is the southeast corner of Broad and Main Streets in the 1940s. The buildings all remain today; only the tenants have changed. In the 1940s, the corner was home to, from right to left, Dick's Shoes, Silver Drugs, A&P Super Market, and Dr. Thomas Hayes' dentist office. The star logo of a Texaco service station can be seen down Broad Street at the corner of William Street.

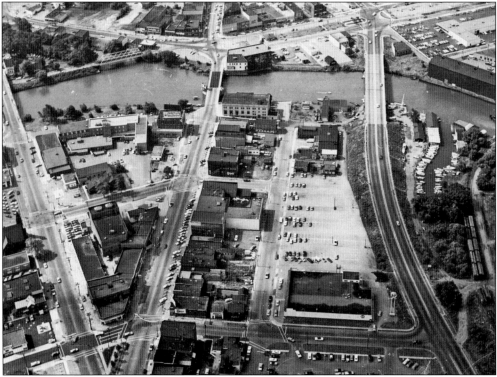

This photograph, overlooking North Tonawanda's downtown business district, shows the newly constructed River Road—Seymour Street Arterial Bridge (upper right). A&P Super Market is in the lower right. The stores and businesses on Main and Webster Streets dominate the photograph. Across the canal, on the south side, urban renewal is underway with most of the businesses on Young Street already razed.

Eight

POPULAR PASTIMES

Most 19th-century factories demanded long hours and heavy manual labor from employees, leaving little time for relaxation. With no television and limited literacy, entertainment consisted of sporting events, live shows like circuses and vaudeville acts, boat excursions, picnics, and community celebrations.

Organized teams in a variety of sports responded to the public fascination with feats of strength and skill and added to the sense of community. Not only did the schools have a variety of sports teams, but many businesses and factories would also sponsor employee teams. The Tonawandas were especially active in football, basketball, baseball, and swimming. The high school football rivalry between Tonawanda and North Tonawanda has endured for over 100 years, with the annual "T-NT" game remaining a popular event even to this day.

As industrialization evolved, so did the fascination with power and speed. Bicycle and horse racing gave way to boat and automobile racing. The Niagara River was a natural venue for boat races, particularly since there were several boat manufacturers in the Twin Cities. Speedboat racing has retained its popularity in the Tonawandas into the 21st century, and although the Richardson Boat Company has ceased operations, cruise and excursion boats still travel the waters of the river and the canal.

Showtime in the Tonawandas meant going to the Rivera (now called the Riviera), Avondale, the Flash, or the Star theaters to enjoy a band concert, a vaudeville act, or perhaps a silent movie. The Rivera had the added musical entertainment of the "Mighty Wurlitzer" organ. Wein's Twin City Band was one of several musical ensembles enjoyed by the community. To this day, the Tonawandas can boast of two American Legion National Championship marching bands from Tonawandas Post 264 and Stephen Sikora Post 1322.

Community events were also extremely popular. Circus performances, parades, field days, and festivals brought the populace together throughout the summer. The tradition of community gatherings continues to this day with the largest summer festival on the canal, Canalfest of the Tonawandas.

Murray Grammar School's 1923–1924 basketball champions pose in this photograph. Built in 1893, Murray School was destroyed by fire in 1938. The school was named for the late Dr. D. W. Murray, president of the board of education. Pictured are, from left to right, (seated) Kenneth Hudnut, Harry Wilde, and ? McNairny; (standing) John Bedell, Arthur Springer, and John Rohrdanz.

The 1921 Tonawanda High School girls' basketball team was ahead of its time, considering most high schools during that period did not have organized women's sports teams. Only two squad members are identified, Florence Krieman (first row, far left) and Eloise Mericle (first row, second from left). The modest uniforms reflect the time period.

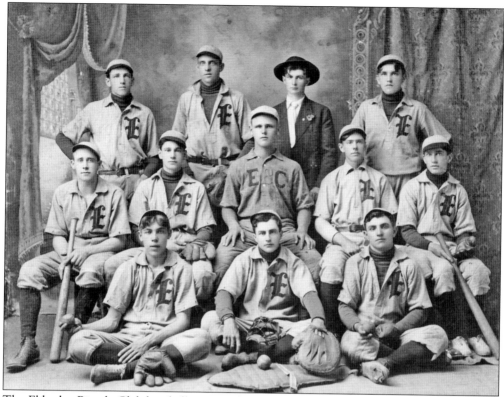

The Eldredge Bicycle Club baseball team is shown in this 1904 photograph. Sponsoring sports teams is a long-standing tradition of the club, and one that continues to this day. From left to right are (first row) George Behrns, Ed Diebold, and Sammy Kineville; (second row) Ben Semper, Jacob Hartell, Frank Grieser, Ray Annis, and Jimmy McQuinn; (third row) Bert Robinson, Warner Bernsdorf, Fred Diebold, and Bill Zuhr.

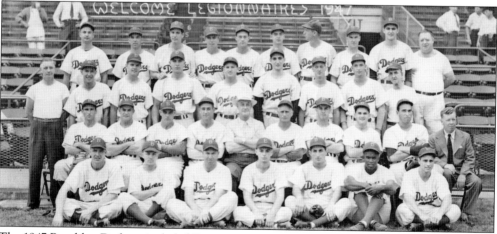

The 1947 Brooklyn Dodgers included Peewee Reese, Gil Hodges, Eddie Stanley, and Carl Furillo. Also on the team was Stan Rojek, a former North Tonawanda milkman. He joined the team in 1941 and later played with the Pittsburgh Pirates, St. Louis Browns, and the St. Louis Cardinals. After retiring from professional baseball in 1956, Stan Rojek returned home and operated Rojek's Park Lane Bowling Alleys. He passed away in 1997.

FRANK A. HINKEY, CAPTAIN YALE TEAM.

One of the greatest of all football teams, the Yale University team of 1894 (pictured below) was coached by the legendary Walter Camp. The captain of the team was "Silent" Frank Hinkey, pictured at left, who graduated from Tonawanda High School in 1889 and entered Andover and Yale in 1891. Weighing 125 pounds, he became the most-feared tackler in the game. At the end of his Yale career, he had been named an All American four straight years. In the below photograph, Frank, as captain, is holding the football with his brother, Louis, next to him. Another brother, Ben, coached the 1905 Tonawanda High School team. On a historical note, Frank is credited with creating the lateral pass in football.

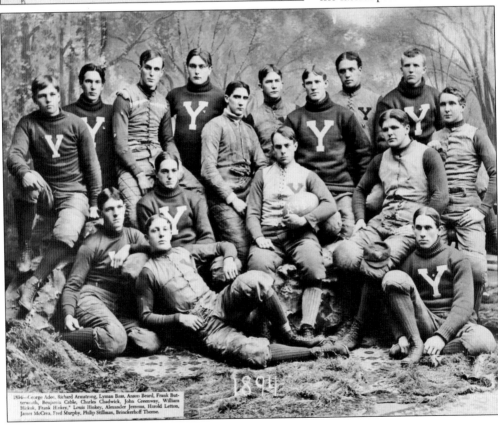

1894—George Adee, Richard Armstrong, Lyman Bass, Anson Beard, Frank Butterworth, Benjamin Cable, Charles Chadwick, John Greenway, William Hickok, Frank Hinkey,* Louis Hinkey, Alexander Jerrems, Harold Letton, James McCrea, Fred Murphy, Philip Stillman, Brinckerhoff Thorne.

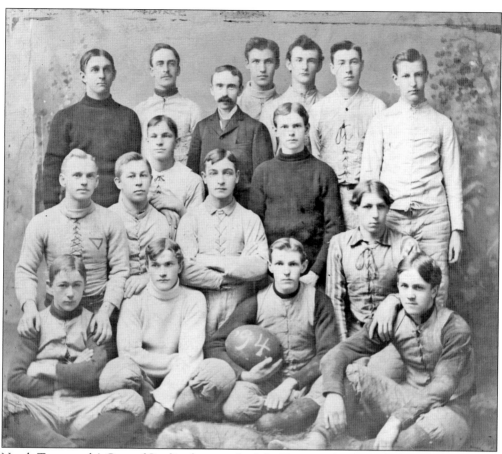

North Tonawanda's Stumpf Studio photographed the Tonawandas' first scholastic football team in 1893, under coach Frank Beardsley. Team members are, from left to right, (first row) Frank A. (Tank) Wallace, James Armitage, Wallace I. Robertson, and Charles E. Hewitt Sr.; (second row) William Blighton, Frank Farnsworth, George Fearman, and Nicholas Wink; (third row) Edward Henneberger and Covert Robertson; (fourth row) Edward Staley, Hiram Meyers, Prof. Frank Beardsley, E. Herbert Smith, Norbert Kropf, Edward Burns, and Raymond Taylor.

Tonawandans avidly followed the "Sport of Kings." This August 1894 race photograph shows Teddie Collins's close victory over Ace of Diamonds at Syracuse's Kirk Park. The owner was Lewis T. Payne of North Tonawanda, son and namesake of the noted Civil War hero. There was a track in Tonawanda at that time known as the Tonawanda Driving Park, which opened in July 1882 and closed prior to World War I.

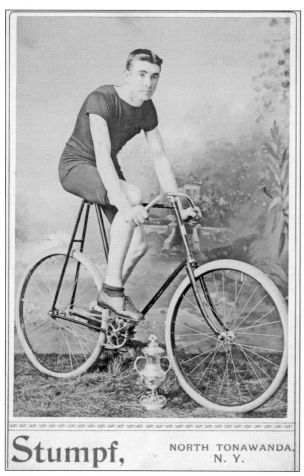

Stumpf, NORTH TONAWANDA, N.Y.

Cycling was the rage in the 1890s. Tonawanda's William R. Blake was heralded as one of the greatest road racers in Western New York. He is pictured here with the trophy he won in a championship race held on July 4, 1892, at the old driving park, located between Main and Delaware Streets in Tonawanda. The 21-year-old Blake finished the race 1/8 of a mile ahead of his competitors.

To celebrate the centennial of American occupation of Fort Niagara, the 25th Separate Company, headquartered at the Tonawanda Armory, planned an 80-mile round-trip bicycle trek to the fort. The 63-member bicycle contingent is pictured here on Webster Street near Sol Goldsmith's Golden Clothing Store. There were only six accidents on the trip, two broken rims and four punctures. One rider was unable to complete the trip due to illness.

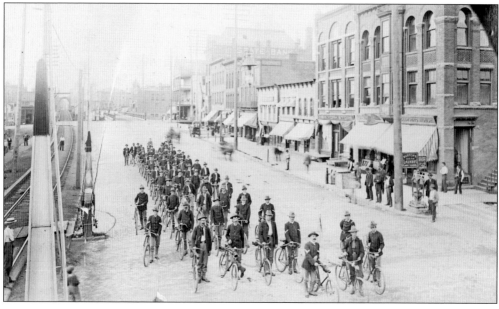

Trained sea lions were a local show business niche. Pickard's Seals was organized by Charles, William, and Harry (pictured here) Pickard, who were all nephews of a seal trainer, Capt. Tom Webb. The acts appeared in circuses worldwide and later on television. After he retired, Harry Pickard occasionally exercised his seals along the Niagara River. Here Harry and Pickard's Seals are shown playing drums and horns onstage.

Four of his trained sea lions hover around Harry Pickard west of the Pickard barn on Broad Street. In the early 1900s, Tonawanda was known as the "sea lion training capital of the world." There were as many as 20 troupes of performing seals that were trained in the city. Three of the best-known seal troops belonged to Pickard, Tiebor, and Herbert.

Over 4,000 spectators attended the 1910 Independence Day celebration that featured a parade, "sham" battle, speeches, water sports, and fireworks. Here onlookers packed the Main and Seymour Street Bridges as 25 contestants walked a 60-foot grease-covered pole over the Erie Canal. Prizes were $1, $2, and $3 for securing the flags placed 15 feet apart on the pole. A live pig, hanging in a sack at the end of the pole, was the main prize.

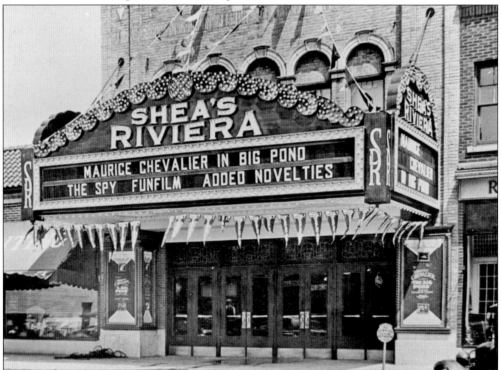

Since its grand opening on December 30, 1926, the Riviera Theater has been the "showplace of the Tonawandas." Designed by Leon Lempart and Sons in the Italian Renaissance style, the interior artwork was painted by Ferdinand Kebely. The theater hosted live stage shows and state-of-the-art motion pictures, and the "Mighty Wurlitzer" pipe organ provided music and sound effects. This historically designated landmark continues to be a performing arts center today.

The Star Theater was the mainstay movie house on the south side of the canal during the mid-20th century until it was razed as part of urban renewal in the 1970s. Patrons remember the manager, Danny Buss, personally greeting customers as they entered the lobby. The lobby was decorated with an ornate fountain surrounded by flowers, plants, and colored lights.

Built in 1914, the Flash Theater at Delaware and Broad Streets in Tonawanda proved to be a popular venue. Residents packed the theater to watch their favorite movie stars, like Harold Lloyd, Norma Talmadge, and Tom Mix, in cinematic favorites of the day. When movies fell out of favor, the building was converted to a roller-skating rink, then a bowling alley, and later a place of worship.

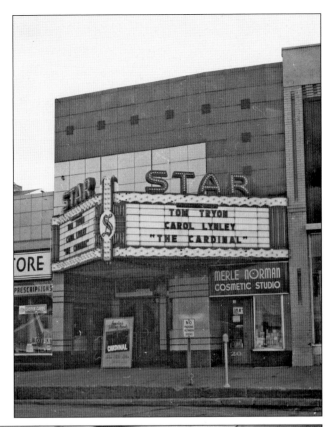

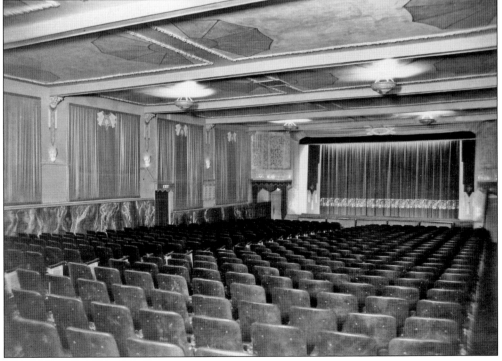

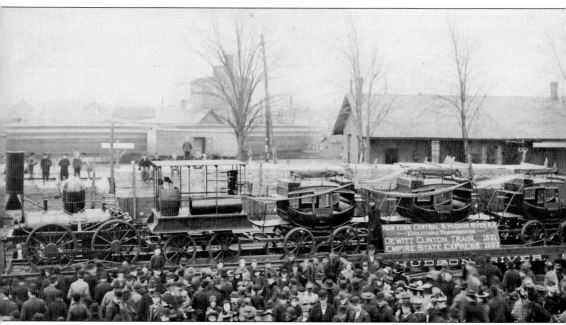

Crowds flocked to the North Tonawanda train station on Main Street in 1913 to view the New York Central and Hudson River Exhibition on the Evolution of Transportation. This nationally touring exhibit featured the *DeWitt Clinton* and the *Empire State Express*, trains that were the first of their kind and symbols of American ingenuity. The *Dewitt Clinton* was the first train to run in New York State and only the third in the nation. Built in 1831 at the West Point Foundry, the locomotive was only the third constructed in the United States for actual railway use and the first to draw a passenger train in the northeast. Early passenger cars were stagecoaches less than 10 feet long and mounted on wheels. Rides were bumpy, dusty, and subject to weather conditions. The *DeWitt Clinton* had a maximum speed of 15 miles per hour and provided regular passenger service for 14 years. The *DeWitt Clinton* missed only one run, when very heavy snowfalls during the winter of 1832–1833 prevented the locomotive from completing its journey.

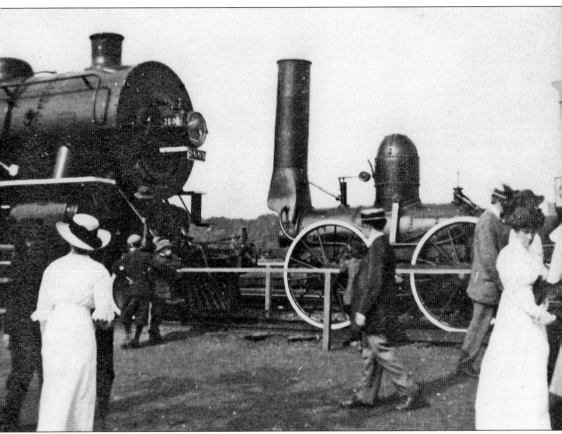

The *Empire State Express* No. 999 is pictured next to the *DeWitt Clinton*. Designed for speed, the train's 37-foot-long steam locomotive was constructed by hand with chisels and hammers and was the first of its kind to have brakes applied to the front trucks. No expense was spared in building this grand locomotive that earned the reputation of being the most beautiful locomotive ever constructed. The locomotive's body had a hand-polished black satin finish; its bands, pipes, and trimming were highly polished brass; and the logo, the *Empire State Express*, was in gold leaf lettering 2.5 feet high. Built in Albany in 1893, the train ran between Syracuse and Buffalo. On May 10, 1893, the No. 999 marked its place in history as being the first thing on wheels to go over 100 miles per hour. On its run to Buffalo, the train reached a record speed of 112.5 miles per hour, setting a world record. The No. 999 provided passenger and freight service for many years and was retired in May 1952.

Embedded in the stone pillars at the Niagara Street entrance to North Tonawanda's Pine Woods Park is a tribute to Carrie Root, a naturalist and wildflower expert. Root along with the Women's Civic Club persuaded city fathers to create a park, a portion of which was to be kept in its natural state as a haven for birds and wildflowers. The park was dedicated in 1927.

A dashing and debonair Charles H. Reimer is pictured in a canoe on a spring day in the early 1900s. His canoe is poised to enter Ellicott Creek, just east of Edith Street. Carney Woods is in the background.

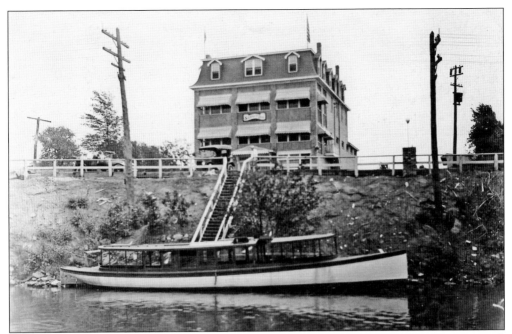

An excursion launch sits in front of the Erie Canal walkway to the Sunset Inn on River Road, about a mile west of the Tonawanda city line. In its heyday, the Sunset Inn was a popular local hotel and roadhouse. Excursion boats, like the launch depicted here, served a large number of local establishments and provided charter service to local picnic groves and parks.

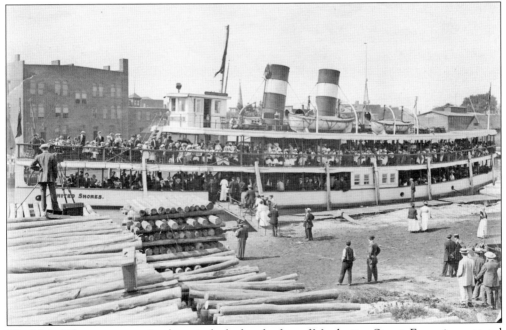

The *United Shores*, an excursion boat, is docked at the foot of Manhattan Street. Excursions around Grand Island with stops at local resorts were a popular pastime. The building at left housed the Eagles and later the Sunshine Mission. The old St. Francis of Assisi Church steeple is near the center of the Tonawanda skyline. Gillie Boiler Shop is at the far right.

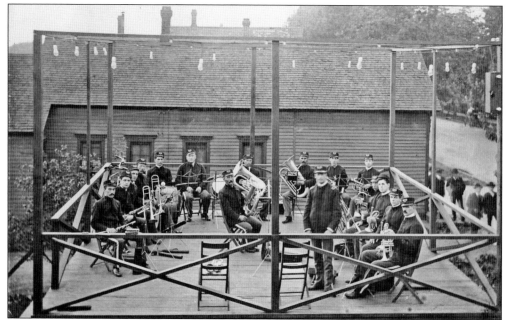

Under the direction of Emil Wein, Wein's Twin City Band was a popular group that played in parades and special events, including concerts sponsored by the Public Market. The band included Godfrey Bernhardt, August Conrad, Henry Haacker, William Hamman, Carl Kepple, Fred Lavendusky, Frank Laverachusky, Alfred Luther, Martin Luther, Samuel McCloy, Michael Miller, Henry Ousterbout, J. R. Simson, Edward Tussing, Henry Tussing, and two John Tussings.

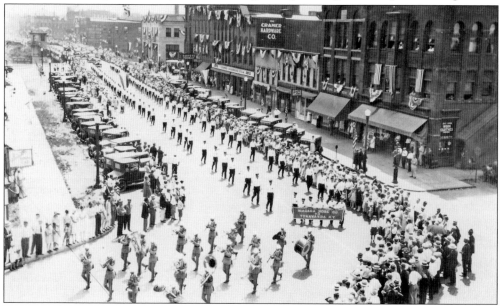

Harvey's Pharmacy and other Webster Street buildings are decorated with flags and bunting as the Niagara Hose Company No. 3 marches by in the Fireman's Day Parade. The parade, an annual event, showcased fire units from Tonawanda and North Tonawanda, who marched jointly since 1911. Firemen were held in high regard in a community where fire was a terrifying threat to frame homes and the lumberyards.

Nine

SERVING NEIGHBORS AND NATION

The images in this volume have profiled the geography, leadership, livelihoods, and generational changes that shaped and built the Tonawandas. Along the way, residents did more than build houses and install infrastructure. They created a sense of community with service to neighbor and nation at its core.

Early on, volunteer firefighters put their lives on the line to spare homes and hearths, as well as the community's vast lumber industry, from the ravages of fire. The fire whistle summoned volunteers to a fire scene with long, short, and numerical signal patterns. The whistle also blew every night at 9:00 p.m. as a curfew notice. Every year at the Fireman's Day Parade, residents would turn out in force to cheer and salute these dedicated volunteers. Fire companies were a powerful political force. On election eve, they would each hold their monthly meeting so that candidates could come by, shake hands, and pay for the beer served that evening.

Also on call 24 hours a day, seven days a week, were the cities' police departments. Keeping the peace has always been challenging, regardless of the times. Burglaries, larceny, and scam artists have always made the newspapers, but headlines seemed to be devoted to local corruption cases, Goose Island "disorderliness," prohibition enforcement, and chasing rumrunners. Water rescues on the Niagara River and the Erie Canal, as well as accidents caused by runaway horses, speeding trolleys, derailed trains, and careless drivers, are found on old Twin City police blotters.

Of the many sites around town, the American flag that flew over the south turret of the Delaware Street Armory for the better part of a century symbolized the community's patriotic spirit. Visible for miles around, the flag stood as a powerful symbol of freedom and a quiet tribute to all who served. Tonawandas' sons and daughters in every generation, from Col. Lewis S. Payne and his comrades in the Civil War to those who are serving today, have accepted their nation's call to duty. The contributions of these local heroes have been forever memorialized by a grateful community.

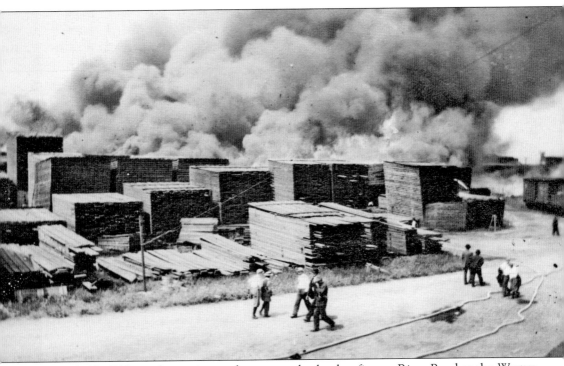

On July 27, 1913, residents witnessed a spectacular lumber fire on River Road at the Weston lumberyard, which was located across from the present-day Riverside Chemical Company. Brisk winds, 9 million feet of dry lumber, and a probable spark from a train engine ignited and fueled a fire that shot flames 200 feet into the air. Heat from the blaze was so intense that it warped train tracks and melted telegraph poles and wires. Flying embers sparked smaller fires at Niagara Radiator and Boiler, Buffalo Bolt, and Buffalo Steam Pump. Fearing for their homes, Ironton district residents began to move out their household goods. Every fire company in North Tonawanda and Tonawanda fought the fire, and the City of Buffalo dispatched its fire tug to aid in the effort. Even though water was repeatedly sprayed on the firefighters, their skin blistered under the rubber coats. They also suffered burns and were overcome by intense heat and exhaustion. Damage to the lumberyard was estimated to be $330,000. Weston had also suffered another lumberyard fire 18 years earlier.

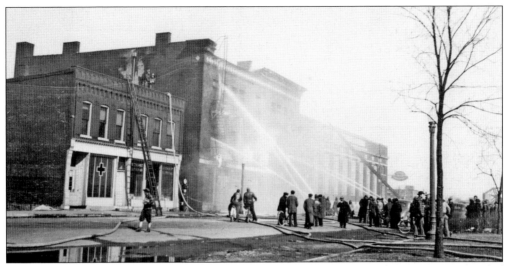

The Sunshine Mission, located at 18 North Niagara between Seymour and Main Street, provided shelter for homeless men. At 3:00 a.m. on March 15, 1938, a policeman spotted a fire at the mission. When firefighters arrived, smoke and flames had engulfed the three-story building. Many residents fled the inferno via ladders that had been put up to the windows at the back of the building by firefighters. One man perished in the fire.

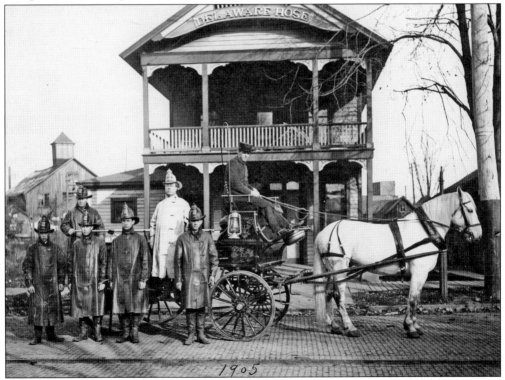

This early photograph of members of the Delaware Hose Company in 1905 features Ben, the white horse. He was purchased in 1900 when the city gave the firemen a wagon to replace the hand-held hose carts in use at the time. Motor-driven vehicles were not introduced until 1922. Pictured in the white coat and hat is Chief Gottlieb Christ.

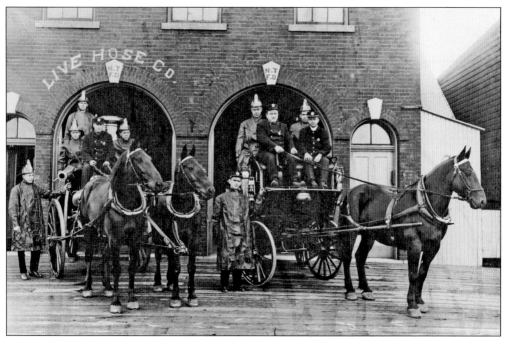

The two engines of the Live Hose Company stand ready for service in this 1910 photograph. The fire hall was located on Thompson Street until 1957. North Tonawanda's city hall was located on the building's second floor until 1900.

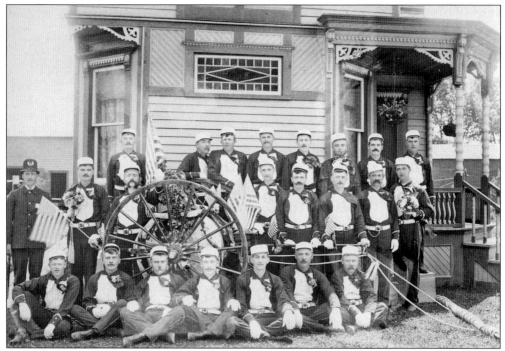

Here members of the recently organized Gratwick Hose Company pose with their pumper on February 10, 1890. The clubhouse, located at 17 Felton Street, was used until 1964. The fire company is now located at Oliver Street and Ward Road in North Tonawanda.

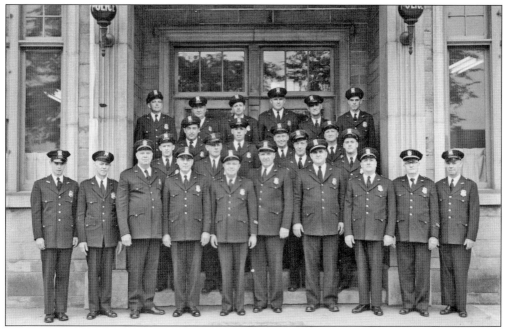

Here the Tonawanda Police Force poses at the front entrance to police headquarters at city hall, 31 South Niagara Street, in 1952. After city hall moved to its new, current location on the riverfront, the building would later house Jenss Children's Department. The green "police" globes lighting the entranceway are now on permanent display at the historical society's museum.

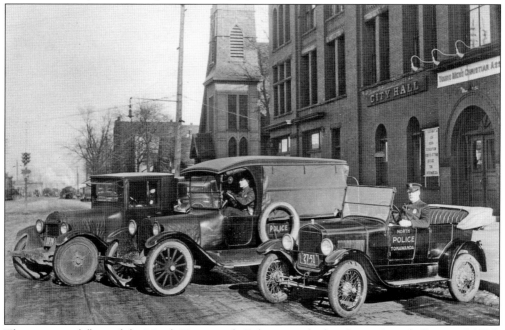

The motorized fleet of the North Tonawanda Police is parked in front of city hall around 1926. The vehicles include a 1924 Dodge, the chief's car; a 1920s Dodge patrol wagon; and a 1926 Model T Ford. The building is long gone, but the church, First United Methodist, remains and is active today.

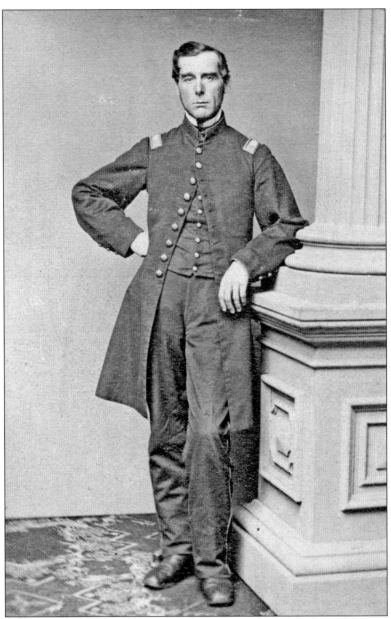

Col. Lewis S. Payne (1819–1898) was a celebrated hero of the Civil War. His grandfather had served in the War of 1812. In the fall of 1861, Lewis Payne was given orders from General Scroggs of Buffalo to organize a company of men. The unit was raised and became known as Company D, 100th New York Volunteer Infantry. During the Peninsula Campaign to take Richmond, the regiment lost nearly half its men at the Battle of Fair Oaks. Payne was a pioneer of commando tactics. In August 1863, while engaged in intercepting communications of the Confederate forces with Fort Sumter, Payne and his men were attacked. Payne was wounded and held prisoner for the remainder of the war. The men of the Tonawandas fought in every phase of the Civil War, from the first battles of 1861, through the three days that shattered the Confederacy at Gettysburg, and into the mouths of cannon charges at Cold Harbor. In later years, these men would meet in their Grand Army of the Republic (GAR) halls to talk of deeds of daring and fallen comrades.

Tonawanda Civil War veterans proudly stand before their Scott Post headquarters on Adam Street. Their GAR badges are clearly visible, as well as various ribbons. The 1898 national convention of the GAR was held in Buffalo.

Members of the Col. Payne Post of the Grand Army of the Republic gather to celebrate Decoration Day in 1917 at Sweeney Cemetery in North Tonawanda. That holiday is now called Memorial Day.

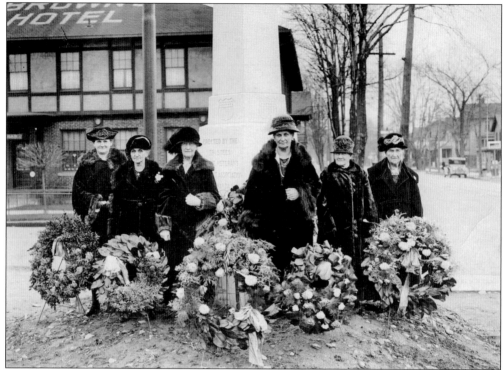

Civil War widows gather to dedicate the memorial honoring those who served in that conflict. The monument was erected at the intersection of Delaware and Broad Streets on November 11, 1925. Now located on the grounds of the Historical Society of the Tonawandas, this monument was moved there in 1942. The ladies were also members of the Women's Relief Corps of the GAR.

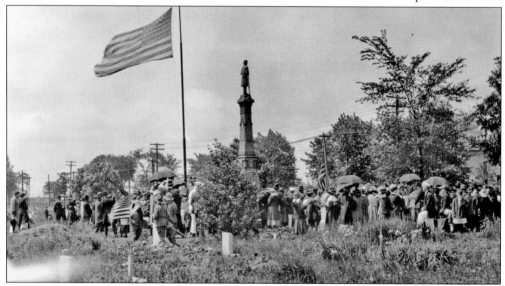

Residents are gathered at Tonawanda's city cemetery on Main Street on Decoration Day to honor all those who served. The ceremony was held near the Civil War monument that was dedicated on May 31, 1910. Located in the old soldier's plot, the monument stands 27 feet high and is a life-sized figure of a Civil War soldier.

The Delaware Street Armory has been a landmark in the city of Tonawanda for more than a century. Originally constructed to house the 25th Separate Company of the New York National Guard, this magnificent stone building was sold to a private owner in 2004, who now operates the facility as a unique venue for weddings and social gatherings. It is listed on the National Register of Historic Places.

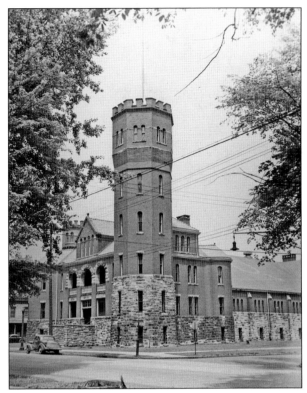

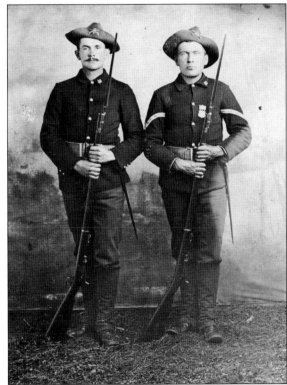

Here two stalwart members of the 25th Separate Company, Pvt. Frank Orton and Corporal Dawley, stand. In 1898, the local company was called up for service in the Spanish-American War. During their service, they became part of the 3rd New York Volunteer Infantry.

DISCOVER THOUSANDS OF LOCAL HISTORY BOOKS
FEATURING MILLIONS OF VINTAGE IMAGES

Arcadia Publishing, the leading local history publisher in the United States, is committed to making history accessible and meaningful through publishing books that celebrate and preserve the heritage of America's people and places.

Find more books like this at
www.arcadiapublishing.com

Search for your hometown history, your old stomping grounds, and even your favorite sports team.

Consistent with our mission to preserve history on a local level, this book was printed in South Carolina on American-made paper and manufactured entirely in the United States. Products carrying the accredited Forest Stewardship Council (FSC) label are printed on 100 percent FSC-certified paper.

MADE IN THE
USA